MW00861013

Soulful Stitch explores and shares the experiences of textile artists working from the deepest parts of themselves, creating work that is meaningful in itself, and healing in the making of it.

Here, textile artists, authors and tutors Cas Holmes and Deena Beverley unflinchingly reveal intimate details of their most heartfelt work, created in extreme personal circumstances which challenged both their creative processes and the two artists as individuals. The process of bringing the book into fruition in such challenging times is also shared, encouraging readers to continue with their own practice even when life throws so many curveballs that creativity seems inaccessible.

Full of practical tips for working in the most difficult of environments, be that living with health issues which compromise energy and mobility, or financial and other pressures, including lack of workspace and time in which to make, these artists have been there, done that and kept on doing it, even, possibly especially, when life had plans for them that didn't seem promising for their continued creative practice.

As this book evolved, the challenges continued, and the artists developed their individual and collaborative approaches accordingly. They share how they did this in the threads of insight gained throughout the making of exciting new work for this book, and in tips on how readers can reboot their own creativity, no matter what else is going on in their life. This is *Soulful Stitch*; a journey from the innermost worlds of two artists working in extreme circumstance, with invited contributions from other artists living through every kind of challenge imaginable, while finding solace, connection, strength, resilience and perhaps most of all, pleasure, through the simple joy of stitch. Open a page, breathe deeply, and begin.

Soulful Stitch

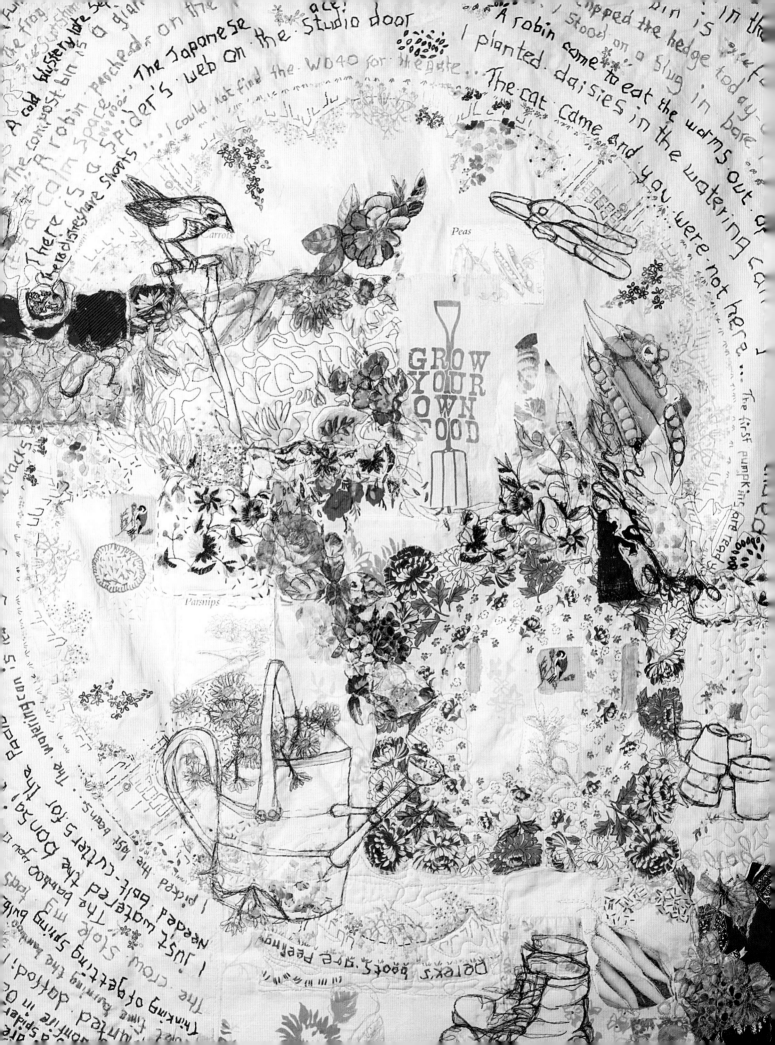

Soulful Stitch

Finding creativity in crisis

Cas Holmes & Deena Beverley

BATSFORD

For Derek, whose journey as a Stroke Survivor has been an inspiration, and for the quiet support, skills and craftsmanship throughout our life together which have provided a space for me to work and create. Equally, to my grandmother and father for their wisdom and 'inherited' Romani ability to adapt and make the 'best of things' as life changes.

Cas Holmes

For my grandmother Rene, an extraordinary person and true inspiration, who encouraged my stitching soul and allowed me to just 'be'. So missed, yet always beside me. For all who share my enduring passion for stitch, a friend which has sustained me through my most challenging times, including the making of this book. Soulful Stitchers all, I dedicate this to you too.

Deena Beverley

First published in the United Kingdom
in 2024 by Batsford
43 Great Ormond Street
London
WC1N 3HZ

An imprint of B. T. Batsford Holdings Limited

Copyright © B. T. Batsford Ltd 2024
Text copyright © Cas Holmes and Deena Beverley, 2024

All rights reserved. No part of this publication may be copied, displayed, extracted, reproduced, utilized, stored in a retrieval system or transmitted in any form or by any means, electronic, mechanical or otherwise including but not limited to photocopying, recording, or scanning without the prior written permission of the publishers.

ISBN 978 1 84994 918 7

A CIP catalogue record for this book is available from the British Library.

10 9 8 7 6 5 4 3 2 1

Reproduction by Rival Colour Ltd, UK
Printed and bound by Toppan Leefung Printing International Ltd, China

This book can be ordered direct from the publisher at www.batsfordbooks.com, or try your local bookshop.

Front cover: *Detail of 'Made in Norfolk (Mustard)' by Deena Beverley. Collaged vintage fabric background, ink drawings; found, original and altered embroidery by Deena, with gold joss paper supplied by Cas.*
Previous page: *'Derek's Garden' (Cas Holmes).*

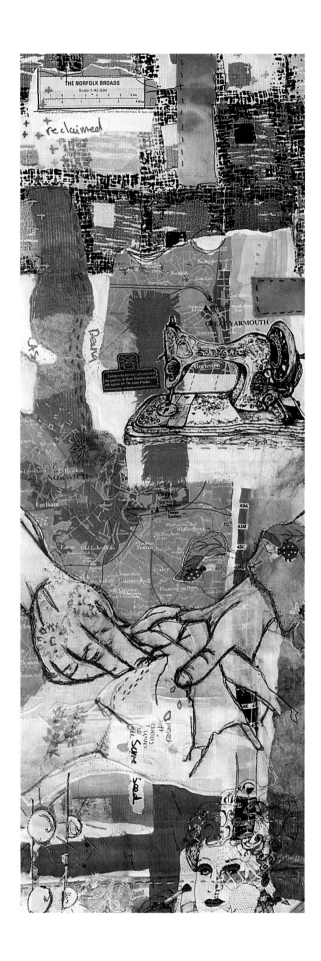

Contents

Left: *Detail of 'Made in Norfolk (Mustard)'. Collaborative panel by Deena and Cas. Deena's great grandmother's Singer sits companionably above Cas's rendition of her hands at work stitching. The background is of mixed-media vintage textiles and paper. Panel 30 x 90cm (12 x 36in).*

Foreword by Deena Beverley

Since childhood, I've found enormous comfort in the humblest materials, enjoying the haptic appeal of crumpled old paper, and the narrative in everyday discards. A shopping list found in a supermarket trolley intrigues with its contents and inspires new work. Wabi-sabi for me isn't a buzzword or trend, but a way of life.

Discards from my own life took on a sudden, enhanced value when my husband and I were evicted at short notice from the extensive studio and workshop complex we had rented, and literally rebuilt from the ground up, over decades. This necessitated a 90 per cent downsize almost overnight, while working full-time and having carer responsibilities. Disability due to chronic health conditions aggravated by stress added to this smorgasbord of stressful events.

As we cleared out the space at speed, it was interesting what we held in high value, saving first. A fragment of cotton parcel string, trodden underfoot, muddied by sodden footprints, I extracted carefully from the tread of my wellies, pocketing it as perceived treasure; I later gilded it with rescued shards of gold leaf that had fallen from a high shelf like angelic confetti onto the dusty barn floor in the forced haste of the move: the prosaic made poetic, tiny glimmers of beauty in the dark maelstrom.

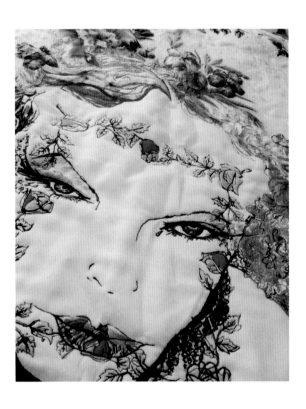

In stark contrast, high monetary value tools and equipment were sold and donated with barely a backward glance. All the while, as leaves whirled around our feet while the winds of change blew, something was shifting, along with the physical stuff and us. The move was seismic in every way, played out as it was alongside other traumatic events in our lives.

I'm a great believer in the old adage 'diamonds are formed under pressure', and during this time, *Soulful Stitch* was conceived. I'd long spoken with Cas about writing a book that reflected those parts of our approach and backgrounds that had informed not just our work, but our whole personal ethos of living authentically – working as if we don't need the money, dancing as if no one is watching. Mobility issues may have put an end to my dancing days, but making this book together has definitely brought the sparkle back to my worn-out ruby slippers; and I sincerely hope that reading it will bring a little of the soul magic that drives us into your life too.

Above: *Detail of 'Beltane' (Deena Beverley). Intuitively quilted, appliquéd and embroidered using found fabrics.*

Foreword by Cas Holmes

As the use of technology increases, I find myself rebelling against the sense of 'perfection' that its use can bring to the 'creative process', preferring to seek out the 'emotionally felt' and the 'imperfection' of the hand-made. I am drawn to the ideas surrounding the Japanese concept of 'wabi-sabi', a respect for the maker's hand, such as the marks that flow from a brush in the making of a scroll, or from the needle when stitching into cloth.

In Deena, I found a mutual respect for the integrity of the making process and a love for creating rich visual narratives extracted from the ephemeral yet familiar materials available to hand. The apparent banality of the found materials I gather is open-ended; these discards constantly inform my work through the prosaic beauty of their ordinariness.

My life partner is a stroke survivor; this has brought considerable change to both our lives and has profoundly influenced how I connect to the simpler things around me as part of my working process. Sharing our experiences of place, of home, and of the past, in the writing of this book has provided intellectual and creative stimulus at a challenging time.

Wabi-sabi has no clearly defined or universally accepted definition in the Japanese language – at best, it can be condensed to 'wisdom in natural simplicity'. You cannot know what is round the corner, so join us in finding the joy to be found in the 'imperfections' of everyday life.

> **Wabi-sabi (侘寂)**
>
> 'Wabi' is simplicity, impermanence, flaws and imperfection – the kind of perfect beauty found in the marks made by the maker's hand in writing calligraphy, as opposed to a machine-printed page.
>
> 'Sabi' refers to the effect that time has on an object and the careful, artful mending of damage; or simple things of daily life that evoke a strong emotional response, such as the transient beauty to be found in spring blossom.

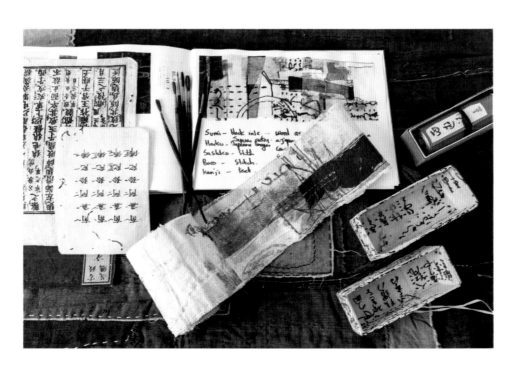

Right: *My father's brushes lie across a sketchbook with work in progress. Marks made on paper or in stitch evidence the signature of the maker. 'Emakimono' (book thing) in progress. Japanese boro cloth lies in the background.*

What is 'soulful stitch'? If it feeds your mind and lifts your spirit; distracts you from life's many challenges; connects you with others, or with parts of yourself you didn't know, or had forgotten, existed – it's soulful stitch. It's salvation in its purest sense. It might not be able to save you from everything life throws your way, but it will comfort, entertain, enrich and enfold you in so many senses that we felt compelled to devote a year of our lives to making this book about it. We live it and we love it. We hope you will too.

What Soulful Stitch Means to Me

Deena Beverley

Stitch has run through my life like the river that flowed behind my grandmother's home above the butcher's shop she ran in Norwich. We'd walk along the riverbank and through the grounds of the almost neighbouring asylum (now luxury housing), and listen to the patients singing in the summerhouses, saying hello to those we passed who were well enough to be able to enjoy the beautiful, extensive gardens.

In the other direction was a cemetery, through which we'd walk while reading the gravestones, having passed the coffin maker whose workshop abutted my grandmother's garden. These walks often ended up in the fantastic classical draper's shop in Norwich, where my grandmother treated me to skeins of stranded embroidery cotton, along with crisp paper transfers to iron onto whatever old fabric she could spare for my first forays into hand embroidery. Kits followed: apple blossom and briar roses on black grounds – I'm still drawn to these motifs now. When older, I'd be allowed to climb out of the window above the shop front and sit, legs dangling from the windowsill, to draw and paint the flowers on neighbouring window ledges, later to replicate them in stitch.

As the production of this book draws to a close, I write this having returned briefly to Norfolk and find myself re-treading these steps. I realize the experiences that were woven here by my own familial experiences with stitch, and with my grandmother's normalization of life, death, madness – from asylums to carcasses, and coffins and cemeteries as playgrounds; it became forged indelibly in me, a sense that all of these things are inextricably linked.

This was, and is, to me soulful stitch. In mending and making, we mend ourselves. We make new connections, and strengthen existing ones. Some threads weaken and break, and we deal with that too. The journey begins with a single stitcher, working a single stitch. Make it count. Make it soulful.

Below: *Detail of 'Kantha' book cover (Opening Doors Within), by Deena Beverley. Found silk and used calico shopping bag scraps.*

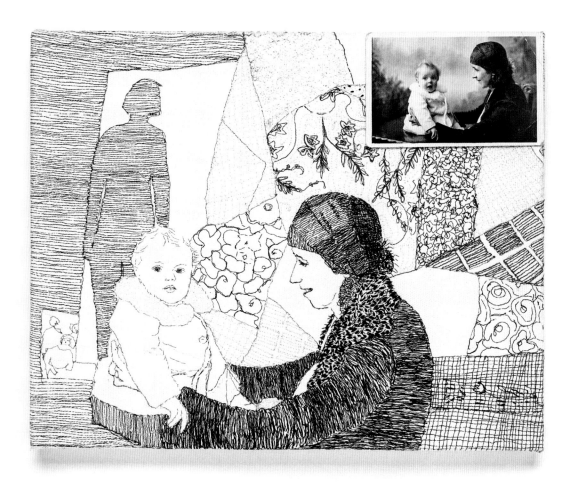

Above: 'Memories of Gran' (Sue Stone). I see this portrait every day as I go into my studio. A shadowy image of myself looks on to my Romani grandmother and my father as a baby. In 2016, Sue invited members of the public to take part in her 'Memories' project by sharing their memories in the form of images and anecdotes. The resulting work inspired by those collected memories was shown in Sue Stone's solo exhibition 'Retellings' at The Ropewalk, North Lincolnshire in 2019.

Cas Holmes

I do not recall seeing my Romani grandmother or my mother working with any form of craft, let alone needlework, yet I have been told both did so when young, and I have no memories of being taught these skills as a child. My grandmother often spoke to me of her family, and of her mother creating small crocheted items and making lacework to sell door to door in Norwich, or when on the road with her family travelling. I do, however, have strong recollections of my father, a trained sign writer, painting beautifully illustrated shop signs. I picked up a brush long before a needle felt comfortable in my hand.

It was not until I attended art college that I 'discovered' stitch; since then, this idea that I can work with a needle as well as paint cloth with colour has remained, entwined with a lifetime's experience of drawing and looking. The quiet, repetitious acts of stitching enable me to respond to the cloth and the stories it carries.

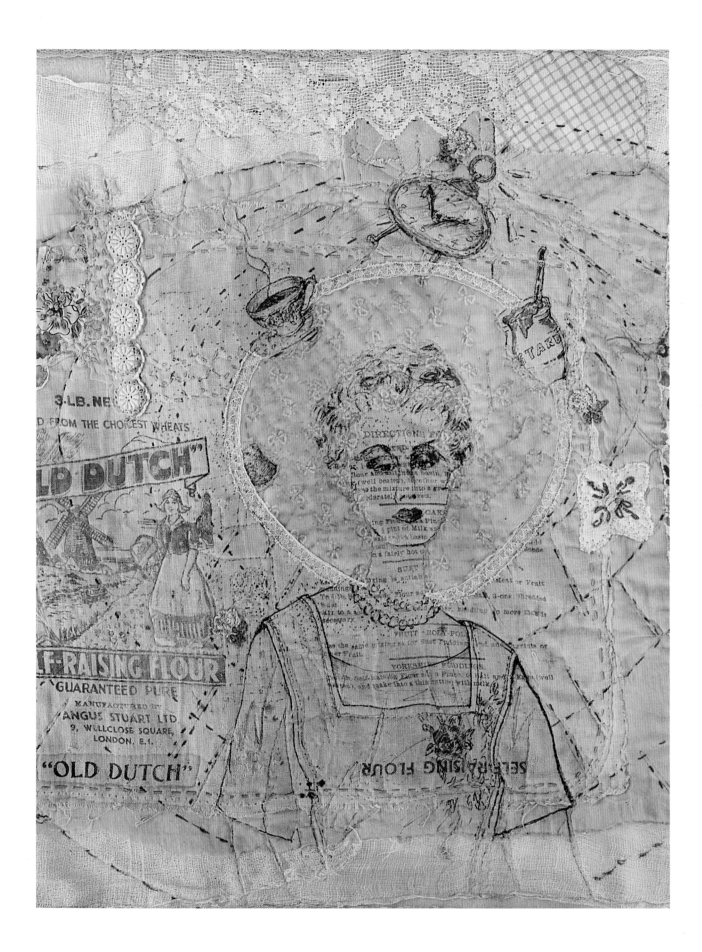

How to Use This Book

'We are all in the gutter,
but some of us are
looking at the stars.'

OSCAR WILDE

Deena Beverley

If I'm in the gutter, I will more than likely be there because I've seen the glisten of an old bottle-top I'm determined to rescue, or a filthy bit of discarded rag or leaf skeleton has caught my eye. Pretty much all material has value and meaning to me. I inhabit a rich and colourful inner world, the management of which in itself is hugely challenging.

Neurodivergent and chronically insomniac, I barely sleep; my mind racing like a multiplex cinema showing many films simultaneously, without walls between each screening. Bombarded constantly with ideas and concerns, many of these I translate into text and textile art, in part simply to release the sheer weight of information running like computer coding behind my eyes. It's exhilarating and exhausting in equal measure. Here, I share my thought processes and inspiration with you, so you may develop the relationship between your own inner life and the art you make.

Soulful Stitch has been developed as a pick 'n' mix of the inspirations and creative innovations that drive the work of its authors and contributing artists. Dip into any page, and you are bound to find something that speaks to your soul. All you need to do is be as present and attentive to your own voice as you are to that of others. Pause. Tune in to yourself. Listen.

Open a page of your notebook or sketchbook, draw in the sand or doodle on a napkin, or make a note on your phone. Record what speaks to you most insistently from any given page. I guarantee I could open this book at any page at any time in the future and have it spark completely new ideas for work and further research and development. The world is in constant motion, as are we within it.

You are holding the soulful expressions of generations of artists within your hands. Now it's time for you to add your own voice. I would love to hear your story and see what you make. Welcome to the world of soulful stitch.

Opposite: *Detail of 'Four Corners' (Deena Beverley). Found fabrics and threads, paper, ink and paint.*

Cas Holmes

I offer the reader a window into my creative practice and the role that found materials and the familiar references of everyday life play in the connections I create between my inner thoughts and the outer world.

The methods I use are accessible and relatively simple; the processing of the techniques covered becomes complex as I evolve the work and develop my ideas. I refer to following 'a line of inquiry' as drawing, observation, recording and touch allows me to learn from the experience I have with the materials. Reusing cloth and other found materials is a form of alchemy: transformed anew using colour, layers and stitching, these discards of daily life allow greater freedom to take risks and experiment.

I work as sustainably as I can with the resources I have at my disposal. Many of the tools and materials used in my mixed-media techniques are relatively inexpensive, sourced from items I find at home, in the garden or on a walk; as well as precious items gifted to me or salvaged from charity shops.

My work process falls into three broad areas, which constantly cycle around each other:

Colour – exploring the use of dyes and paints with simple tools;

Layer – different paste and paint approaches to creating collages and three-dimensional pieces using collated found materials;

Stitch – discovering what we can achieve through the interplay between machine and hand embroidery.

The creative process is not easy. We can all feel a little overwhelmed or struggle when embarking on a new course of work. The last few years have been a step into less familiar territory, and I have needed to evolve different ways of working as I carve out time for my own practice. At times, it has been a little terrifying, yet I have come to recognize that this is a totally normal feeling when undertaking something unfamiliar. Doing something that 'slightly terrifies' us pushes our learning forward and helps us discover where we want to go. As we become more familiar with the unfamiliar, it becomes less terrifying.

Allow the ideas shared by the authors and artists within this book to act as your guide as you explore and think about the precious pieces you want to use to create meaningful and personal artwork.

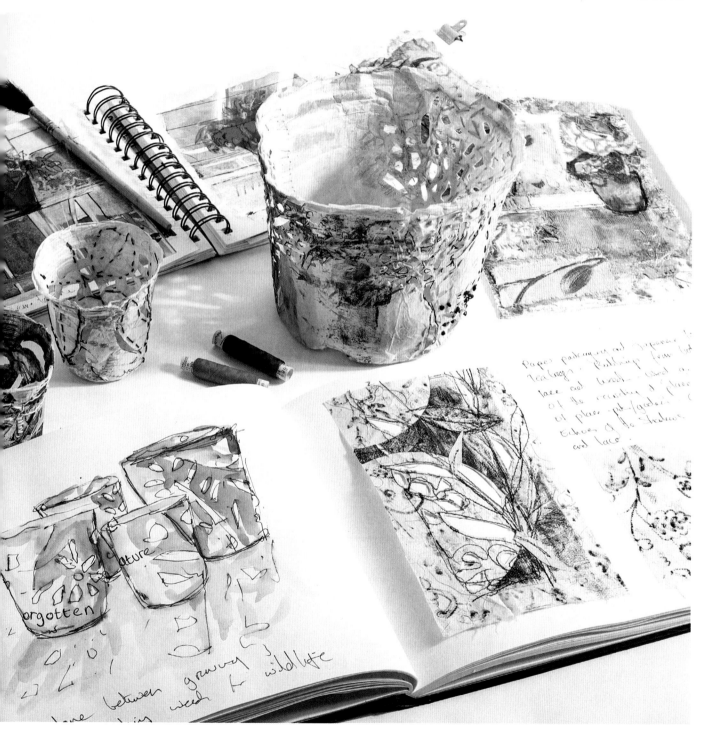

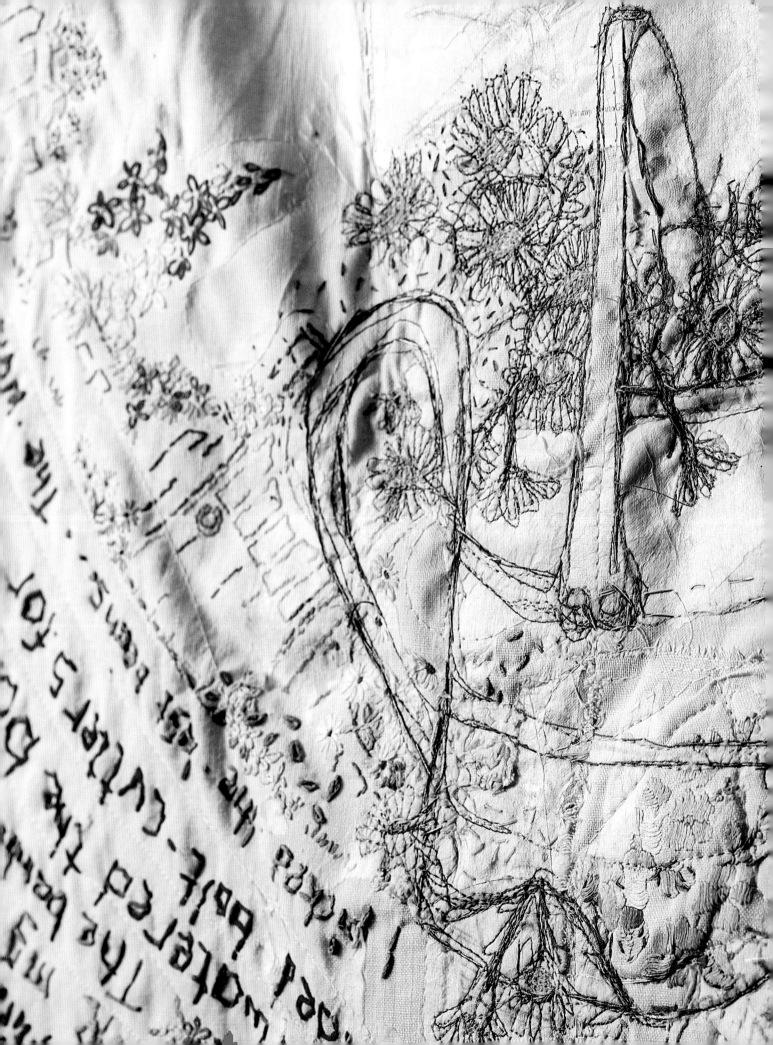

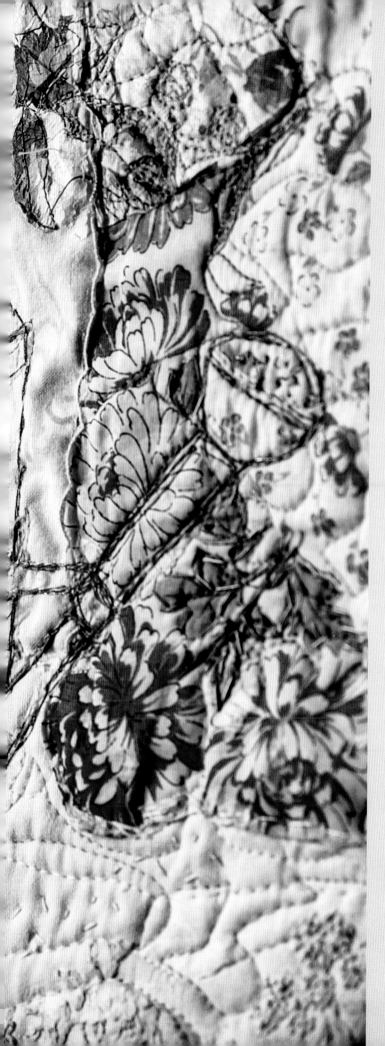

In Extremis

Left: *Detail of 'Derek's Garden' (Cas Holmes). Text relating to the garden stitched onto fragments of cloth. Poignantly, the first piece of text stitched was Derek asking if I had 'picked the last beans'. This was a sign he was coming back to me. Hand- and machine-stitch collage worked onto a tablecloth.*

In Extremis

Sometimes life doesn't so much throw a spanner in the works as the whole damned toolbox. Finding enjoyment and creative purpose in life's toughest times can feel near impossible when surviving the day is a genuine achievement. That's no exaggeration, for throughout this book we share inspiration from those who've walked the walk, even when walking wasn't possible. Here are tales of hope and inspiration, songs sung from the front line of living in extremis, with art as both comfort and creative outlet.

Deena Beverley

We've had to surmount extreme circumstances to produce this book; united in feeling we were, and are, 'creating in chaos'. The struggle is real!

I've interviewed many icons of embroidery who've had to adjust to difficult life circumstances. Jane Lemon MBE; the late, great, ecclesiastical embroiderer, was frustrated at the cancer treatment which hampered completion of her epic 'Prisoners of Conscience' piece for Amnesty International. Asked how she dealt with the difficulties of working with failing eyesight and other health issues, she responded simply, 'I just worked bigger'.

The late textile luminary Rozanne Hawksley is another inspirational example. She'd survived so much tragedy it was difficult to render her story palatable to a mainstream embroidery magazine audience. Her work fearlessly confronted and exposed that which we prefer not to acknowledge, and the pain she and her family had suffered had clearly gone into her powerful art.

Conflict, abuse of power, poverty; big life and death issues were her palette. 'War and Memory', her 2014 retrospective, took an unflinching approach to what she called war's 'terrible glamour'. Loss, love; all human suffering featured delicately, insistently, potently in this tear-jerking monumental exhibition.

In my written and stitched work I have a strong sense of honouring embroiderers who've survived and thrived in extremis; who've told me their stories; some in person, others through legacy.

You don't need to be a professional textile artist to make creating in extremis work for you. Make a little. Make lots. Make none at all; enjoy the work of others. All are valid. Sometimes all we *can* do is survive. As the late Nell Gifford of Gifford's Circus memorably said, 'sometimes you just have to go horizontal'. I have a sneaking suspicion though, that when the dust settles, you'll want to create again. It's hard-wired into us, and it helps.

> *'In the depths of winter, I finally learned that within me there lay an invincible summer.'*
>
> ALBERT CAMUS

Cas Holmes

In early September 2021, following a busy day working in the garden, Derek, my partner, had a catastrophic stroke. I watched on mutely while he was bundled into the ambulance, unable to follow due to the COVID restrictions that were still in place.

That any creativity was possible at all during this time is hard to imagine, yet somehow, the following morning, I found a quiet calm in sitting and drawing the pruning tools left on the table from the night before. My hands needed to be busy – no plans, just doing – to calm my worried mind. Gardening, drawing, or stitching began to punctuate my days between the odd hours I could visit the hospital over the months that followed.

At a time when I was getting ready to get back in the world and resume my work as a 'travelling artist', my life was put on hold. I continue to struggle to find a way to balance caring responsibilities with my art practice and teaching. Stitch remains at the heart of my work and my need to communicate, as I reconcile myself to a role that has transformed into that of an 'artist/carer'.

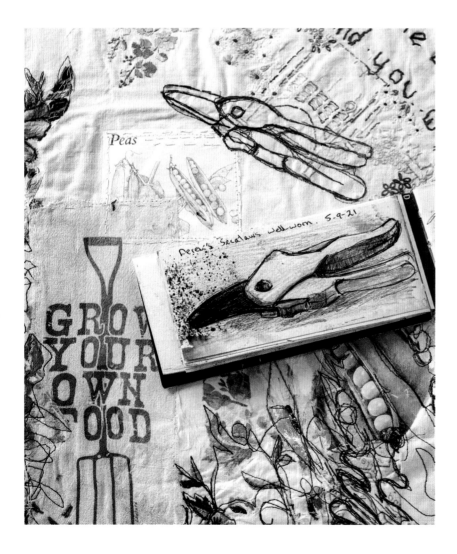

'At the end of the day, we can endure much more than we think we can.'

FRIDA KAHLO

Left: *The first drawing. Secateurs, left on the table from a day of pruning, dated on the day Derek was taken into hospital. The drawing sat beside me as I machine stitched it directly on the work.*

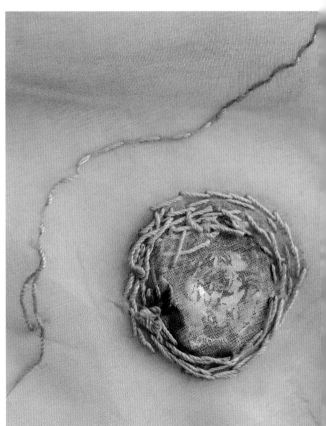

The Extraordinary Ordinary

When we are hit by a global pandemic, mobility issues, illness, carer responsibilities, financial limitations, or any other constraints life can place on us due to circumstances beyond our control, our experience of the world becomes smaller, confined to that which is immediately within our diminished orbit. Learning to regard these times as creative retreats, opportunities to focus on the beauty to be found in the everyday, is a valuable creative process in itself – you'll be surprised at what you can see.

Pavement Treasures Series

Deena Beverley

When mobility issues forced me to reduce my customary high-speed walking pace to a slow, painful shuffle with walking aids, journeys to and from town started to take longer, becoming increasingly fraught and frustrating. Where previously I'd zoomed along, now I could no longer look up at what was in front of me, let alone the sky. Every step is a potential fall in the making. The pavement and road surfaces have become my 'new sky'. In this topsy-turvy world I now inhabit, I have discovered that there are stars here, too.

These 'pavement treasures' filled first my pockets, then my trusty seated walking trolley. A stable object with more reliable balance than me, it gives me something to sit on during the many breaks I need on even the shortest walk; a place to perch and contemplate the treasures I collect while roadside foraging, planning future work. Discarded bottle tops found in the road are my favourite finds. Repeatedly driven over, they become 'street sequins'. If they have wording on them with some implied significance, I'm thrilled, but I cherish them all for their beautifully corroded soft patina; worn paint yielding to the still-bright metal beneath.

There's also an amazing array of discarded textiles, usually wet and filthy, to be found in the gutter. These I pick up gingerly with a long-handled grabber, placing them in a plastic bag I keep in the front pocket of the trolley. I take these precious rags home and peg them out on the washing line immediately, for multiple rain-laundering and wind-drying sessions before washing them myself. Do the neighbours in our shared-access terrace think the lady with a washing line permanently full of filthy rags is crazy? Probably. Do I care? No, not when one such find was the ripped polka-dot bandana that became part of 'Kantha Cowboy' (I am putty in the hands of found red polka-dot cotton; so soft, so cheerful, so pleasingly nostalgic).

Nature, of course, brings seasonal offerings aplenty. Sycamore 'wings', leaf skeletons, poppy seedheads; the list is endless, and endlessly inspiring. All are squirrelled away and taken home to add to my burgeoning collections of such treasures, awaiting their chance for new life, and new appreciation. Carry a foraging bag on your everyday travels: you'll be amazed at what you find, and delighted at what you can do with it.

Opposite: *Details of the 'Pavement Treasures' series (Deena Beverley). Foraged materials, found papers and threads, tea-dyed found fabrics.*

Pavement Treasures Techniques

Deena Beverley

There is attention to detail in every aspect of what the Shakers created. The underside of a chair, for example, was as beautifully considered as its seat. When exhibited, my 'Pavement Treasures' require individual, unobtrusive suspension systems, enabling them to be hung and viewed from all directions.

When visiting *Quilts: 1700–2010* at the V&A, I was particularly drawn to the exhibits where the backs of the quilts were visible, notably the writing used on papers in the English paper-pieced patchwork. Ephemera is a key component of my work and I wanted people to be able to see every aspect, including the reverse of old papers, cotton-reel labels, and my imperfect stitch, all integral to the pieces as they developed organically. To retain the delicacy of single pieces of fabric, I didn't want to fold over their top edges to make an integral sleeve. I wanted the suspension method to be as 'meant' as every other stitch on the piece, rather than applied as an afterthought.

Couronnes (which means 'crowns') are versatile freestanding embroidered eyelets that have multiple uses: as a motif to apply to work, as a cheat's shisha, and as a suspension method, as seen here. The classic buttonholed couronne is a circlet of self-supporting stitch worked around a former. A couronne stick is a pleasingly sculptural tool with steps cut into it, enabling different diameter rings to be made; however, knitting needles, dowels or cocktail sticks may all be pressed into action, and kebab skewers, too, as I've used here.

I often subvert classical stitch techniques for my own ends, and this was no exception. Rather than conventionally making stand-alone couronnes, the method I devised enabled me to work them directly onto the suspension rod (also a kebab skewer – lightweight, unobtrusive and toning beautifully with the colours in my piece), while simultaneously securing it to the fine silk organza. It also left two lengths of thread with which to add more stitch to the piece itself, properly integrating and relating the couronnes with the rest of the work as intended.

'The peculiar grace of a Shaker chair is due to the fact that it was made by someone capable of believing that an angel might come and sit on it.'

Thomas Merton

Opposite: *Kantha and shisha needle case (Deena Beverley).*

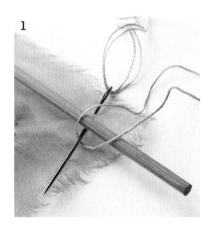

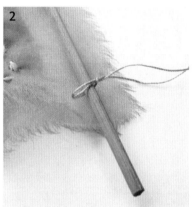

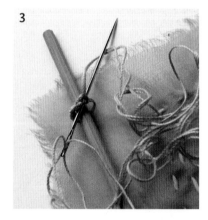

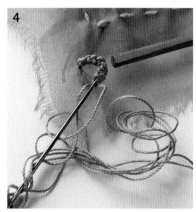

Making Couronnes as a Suspension Method

You Will Need

- **Couronne former:** conventional couronne stick or any stick to hand for the size of couronne required, from kebab stick to broom handle or bigger (I've even used kayak oars)

- **Thread, yarn, fibre of choice:** although I love to use found vintage threads in my work, since their fortitude may be questionable, I used new silk thread here (in the past, I've used everything from single fine strands to sturdy chandlery rope)

Method

1 Double up thread and hold the centre of the doubled thread against the stick (former).
2 Pull taut, but not so tightly you won't be able to remove and replace the former. Work a single buttonhole stitch around the stick to secure the thread to it.

Note: To attach to fabric as a suspension method, thread your needle with one strand of the doubled thread. Take this through the fabric and back again a few times, securely attaching the couronne to the fabric.

3 Thread the needle with both strands of thread. Work buttonhole stitch all around the thread on the couronne former, pushing each stitch up close to the previous stitch until the whole circumference of the thread circlet is covered, making the last buttonhole stitch through the first one made.
4 Bury the thread in the couronne before snipping off the end.

Note: If using as a suspension method, continue to stitch into your piece with the remaining thread.

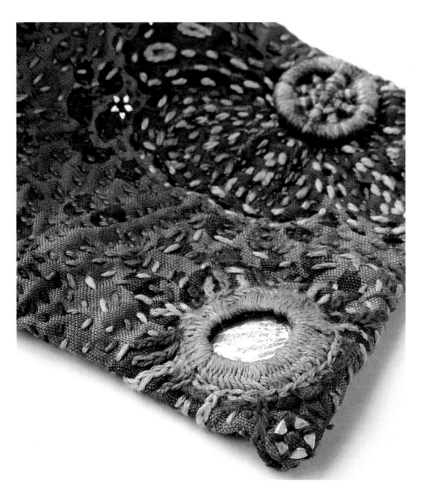

Making Cheat's Shisha Crowns

Couronnes can be used to add all manner of found objects to your work, including coins, bottle tops, shells and pebbles – the pavement, beach and garden will yield treasure aplenty.

Method

1 Make a couronne with an internal diameter slightly smaller than the item to be attached.
2 Place the item onto the background where desired; secure with a dab of glue or double-sided tape if you wish (I prefer not to as I like the slight movement of items only secured with stitch).
3 Position the couronne over the placed item and stitch in place with contrasting or toning thread.
4 Make the stitches as unobtrusive or as decorative as you like. Extend the stitching as desired.

Derek's Garden

'As the soil, however rich it may be, cannot be productive without cultivation, so the mind without culture can never produce good fruit.'

SENECA THE YOUNGER

Cas Holmes

Gardens and the green spaces around us offer us a place to relax, to grow things, and, for the textile artist, visual stimulation. It is no surprise that flora and garden subjects feature heavily in historical embroidered work and are still favourites for textile artists today.

I am now the 'worker' in the garden, not the 'watcher', taking over the heavier jobs that Derek cannot do. I often sit with a cup of tea and a sketchbook, noting down small discoveries as I work, from the worn and often-repaired garden tools, loved for the way they sit in my hands, to the growing plants and vegetables. The act of gardening became a balm for my worried mind.

While stacking and organizing piles of vintage linen one autumn evening, my eyes lighted upon some garden flora trailing across the fragments of an old tablecloth. I extended the circular pattern on this forgotten embroidery with hand-stitched text to reflect my own 'garden discoveries'. These small moments of creativity were all I could manage at the time, and the work was calming. These fragments were applied to a base cloth with cellulose paste in a process I refer to as 'wet appliqué', which helps to stabilize the materials prior to machine stitching.

I found some simple line drawings in a gardening book that reflected the vegetables that Derek had planted in the garden earlier in the spring, now growing in abundance. These were also transferred onto the cloth with acrylic paint. Tucked in the corner of the greenhouse, I found some weather-worn seed packets and snippets of string used for tying up the peas and tomatoes. These were added to my collection of 'lost things', to apply final details with a combination of free-motion machine embroidery and hand stitch to create a celebration of Derek's garden.

The act of gardening provides a familiar respite in a world that can sometimes lack that quiet calm. Each spring, the small daisies tenaciously push their way through the cracks in our paving. Daisies are symbolic of hope and new beginnings, a reminder that I need to nurture myself and snatch moments of time, when I can, to continue my practice and to garden. Derek and I are both 'stroke survivors'.

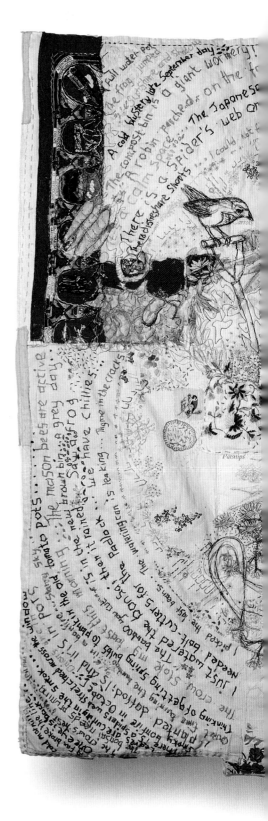

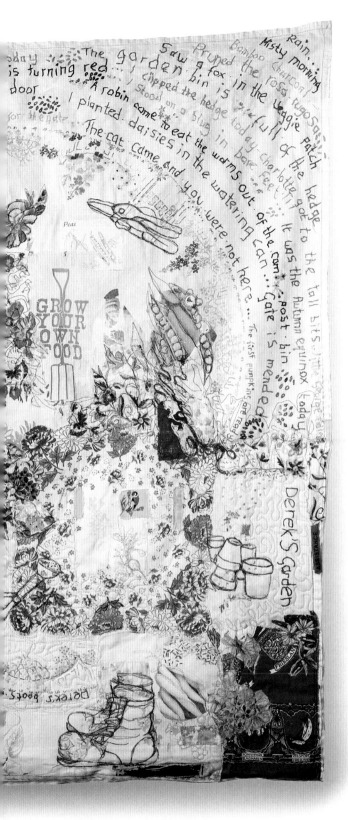

Above: *Tools and written observations feature in the machine- and hand-stitched details, including Derek's watering can, which is now planted with daisies. 110 x 120cm (43 x 47in).*

Wet Appliqué

In the construction of my work I use a process I refer to as 'wet appliqué' or 'lamination', using methylcellulose/CMC or wallpaper paste to layer paper and cloth. When dried, the paste temporarily holds the materials together and removes the need for stabilizers prior to free-motion stitching. It is the stitch that ultimately holds the work together. CMC paste comes in powder form and easily mixes with water. It is made from cellulose, a substance occurring naturally in plant matter.

To Mix the Paste

Sprinkle one tablespoon of CMC powder into 250ml (9fl oz) of cold water (or as directed by the manufacturer), stirring continuously for one minute, then leave it to stand. Thoroughly stir again. The paste should be about the thickness of double cream, or thicker, depending on the weight of the materials you are using. Add more water if it is too thick. I find it useful to test by pasting up a few samples and leaving to dry.

I usually keep my paste in a large glass jar and store it in a cool place or in the fridge.

Method

1 Lay a sheet of plastic or baking paper on your working surface.
2 Place your cloth and papers on top of one another, brushing paste onto the layers as you go. Move the pieces around as you build your composition.
3 The layers should have good coverage and be very wet to the touch.
4 Mop up the surplus and leave it to dry flat on your work surface.
5 Once dry, gently peel off the supporting plastic or baking parchment.

The temporary nature of the paste adhesive allows you to move things around easily and the paste is generally quite flexible. If you want a more permanent fix or to strengthen without stitching, then you will need some other means of attachment, such as iron-on stabilizers or fabric glues.

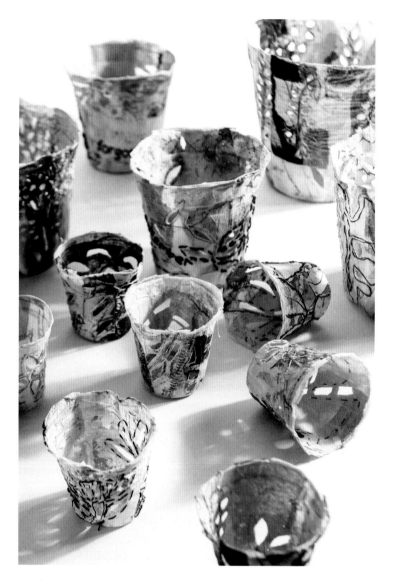

Cultivate

Cas Holmes

Stashed in the greenhouse and in the shed, ready for spring planting, sit a variety of beautiful clay, and less impressive plastic, garden pots. Cracked and worn with age, they are a gentle reminder of the learning I have undertaken as a gardener in cultivating plants, both for our table and for wildlife. I often sit and draw these pots, enjoying the shadows that reflect on them. Collating tissue, plant material and fine lace, I explored methods of layering these materials with paste, using old plastic pots as moulds, to create three-dimensional paper replicas of these much-used and well-loved pots. When dried, the flexibility of the plastic allowed me to 'peel' the layered structure off the support, rather like a sock. Negative shapes were cut out from the surface of these imperfect forms to echo the shadows of plants on the walls and paving slabs. Hand-stitched embroidery followed some of the patterns to create a lace-like effect. In cultivating the germination of the seeds, I am equally cultivating my creative time.

Above and right:
'Cultivate' (Cas Holmes).
A growing collection of
paper-moulded pots.
Shadowy text transferred
from gardening magazines
sits on their surface. These
pieces were commissioned
by the Romani Cultural
and Arts Company for the
Gypsy Maker exhibition.

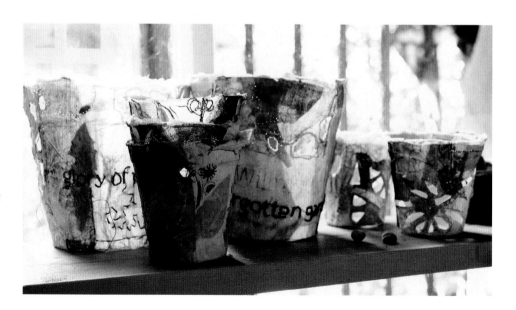

Imperfect Memories:
Transferring Images onto Cloth

Cas Holmes

Images found in old magazines and books can work well with mixed-media textiles that have a vintage feel. The subtle, faded imperfections of the garden series are achieved by transferring images with acrylic paints and mediums, or even household paint. The quality of the transferred images varies and is not intended to be perfect. The results achieved by using this low-tech method, in combination with the pattern and colour choices of your cloth, can help capture a sense of place and time.

The Basic Process of Image Transfer

1 Place your cloth on plastic sheeting.
2 Coat the image you want to use, print side up, with a good layer of paint or medium.
3 Place the coated paper face down onto the cloth and press firmly. You may want to roll the image down with a printing roller to ensure good contact. Leave it overnight to dry.
4 Wet the back of the dried image with a sponge for a few minutes, then use the sponge to gently rub the back of the paper away to reveal the image.
5 Leave to dry; if there is still paper fuzz on the picture, repeat wetting and rubbing away until you have a clean image.

Explore the possibilities of using embroidered or patterned cloth as a base instead of plain cloth, or apply colour such as Brusho®, inks, dyes or fabric paint to your image.

When building up your images and selected cloth into a collage, try out different options and move things around. Work on two or three collages at once, taking photographs of different variations. Allow yourself time to play around with the balance of the composition.

Below: Cloth and paper used in the transfer process using photographic images from gardening magazines and books.

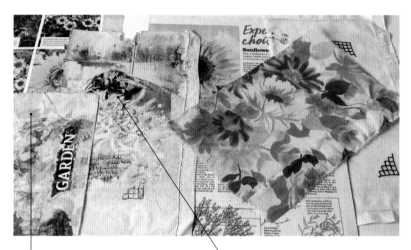

Patterned floral cloth transferred with Acrylic Matt Medium (floral cloth on the right). The word 'Garden' is left 'unremoved' from the rubbing away process.

Bee image on a tablecloth (the original linen tablecloth can be seen on the far right), transferred with cream household emulsion paint. Elements of the original embroidery show through the paint.

Left: Detail from 'Derek's Garden' (Cas Holmes). Free-motion machine stitch overlaying illustrations from an old gardening book.

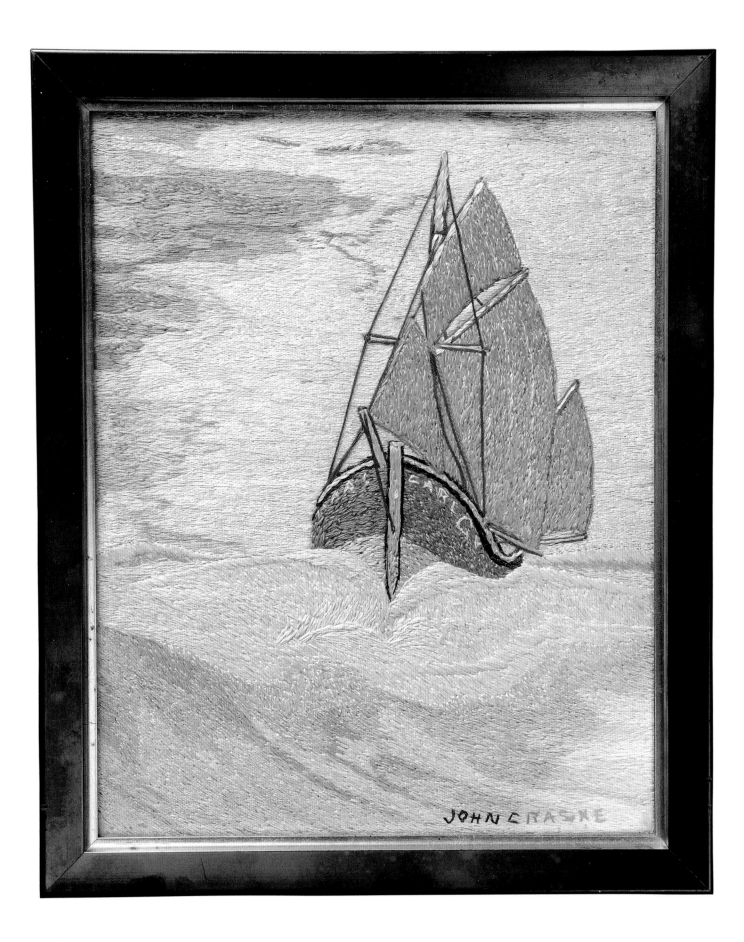

Comfort and Consolation:
John Craske – Telling Tales of the Sea in Thread

Deena Beverley

My grandmother introduced me to John Craske's work. I'd never actually seen his pieces in the 'stitchy flesh', but her enthusiasm about the work of the 'fisherman too ill to fish, who embroidered marvellous pictures' of the ocean he missed, determined me to seek them out.

Craske became landlocked due to severe ill health, which blighted almost his entire adult life. Encouraged by his wife and his doctor, who suggested that, when too unwell to stand up and paint, Craske should switch to thread, he created a world that consoled and comforted him; in making the work and in its subject matter.

Often described as a folk or outsider artist, Craske's work is actually accomplished, particularly his embroidery, which is more finessed than his paintings. Perhaps hand embroidery's slowness, necessitating stitches to be meticulously placed, compared to oil paint's speedy coverage, forced Craske's hand, to the work's benefit.

Craske's embroidery foretells contemporary hand embroidery's dynamism, remarkable considering he created these pieces from his sick bed in a small Norfolk market town; barely speaking, and rarely leaving his room. His imagination, though, travelled widely, journeying through diverse sea-based memories, creating colourful, textural, dramatic images exquisitely realized in hand embroidery.

Some, once displayed in bright sunlight, are faded; pale as a Norfolk beach on a winter's afternoon; bleached bone and cool icy ribbons where once were blue skies and sands of gold, but still sublime in their impressionistic rendition. Others remain as luminous as when first stitched.

Holding these precious works in my hands, along with painted postcards Craske gifted to his supporters, such as the doctor who encouraged him, telling him 'the sea will save you', I felt strongly connected to Craske who, like me, had found himself incapacitated in a small Norfolk town. Largely unable to speak (I too have at various points in my life been electively mute due to extreme stress, and confined to bed and to my room through illness), he found freedom, distraction and even companionship through the meditative medium of stitch. Perhaps it was not so much the sea, as the stitching of it, that saved Craske. I know how he felt, and hope you discover this feeling too.

Opposite: *John Craske's hand embroidery on unidentifiable background. Sealed frame, likely to be reclaimed canvas.*
Below: *Detail.*

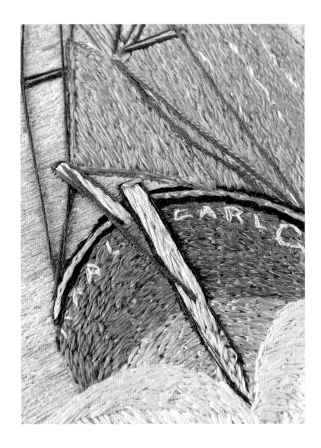

Slaves to the Wind

Deena Beverley

Typing this title under pressure to a deadline, I mistyped the word 'Salve'. When predictive text misfires, what appears instead of my intended wording is so interesting. Like a Freudian slip, the mistyped word often reveals my true feelings: not what I'd intended to type, having run my emotions through the mincer of intellect and self-editing.

I'd been ambivalent about calling this piece 'Slaves to the Wind', words which were found in an old embroidered textile as part of a larger sentence and added to this work. Although we're all slaves to the wind, buffeted by fortune's winds, in many ways unable to control or predict our destiny, my central message here is my oft-repeated mantra: 'When seas are rough, mend your nets.'

My mother's version of the same saying was more homely, yet no less profound: 'If you're going to be miserable, you might as well be miserable with a tidy knicker drawer.' Throughout childhood and adolescence I spent more time at home than I did at school, unwell with a series of physical and somatoform illnesses. Confined to the home, and in a frankly dreadful state, I would attempt to take my mother's sage advice. I've passed on her wisdom to anyone who will listen ever since. It works.

'I must go down to the seas again, to the lonely sea and the sky

And all I ask is a tall ship and a star to steer her by'

From 'Sea Fever' by John Masefield

Below: *Details of 'Slaves to the Wind' (Deena Beverley).*

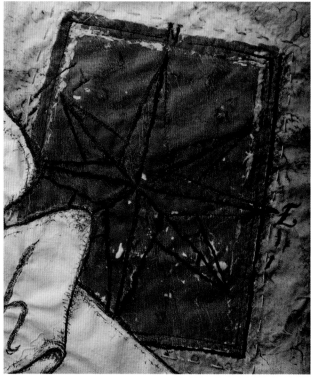

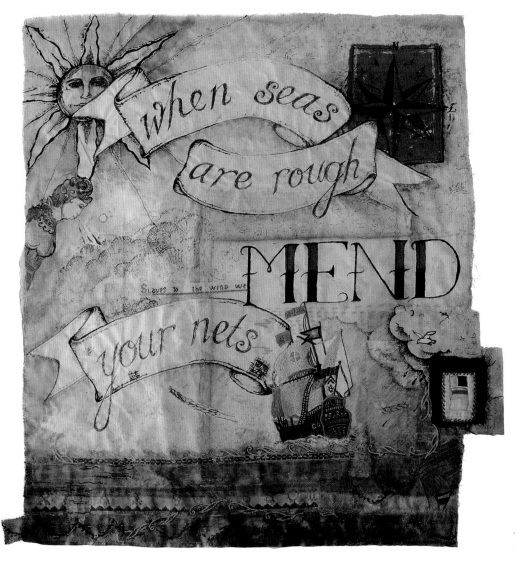

Left: *'Slaves to the Wind'* (*Deena Beverley*). *Hand-drawn lettering with embroidery on found fabric, with painted and stitched found additions.*

When illness or other challenges prevent us from the kind of forward momentum we'd prefer, there is always a virtual knicker drawer to tidy, or a net to mend when storms rage too strongly for us to set sail: whether that's clearing old pictures off your phone or deleting emails, there's always something you can find to do that will, beyond the current challenging situation, have made a positive difference. It's likely you won't feel remotely like doing it, but as my mum said, you'll have a tidy knicker drawer at the end of it, and you'll have kept your hands and mind occupied during the worst of the storm.

That's what John Craske did throughout his long years of illness, and this suitably nautical-themed piece pays homage to the legacy of finding salve in stitch; to the importance of finding your own True North, setting your compass and heading in that direction, even when you feel like you're going nowhere.

Slaves to the Wind Techniques

'To invent, you need a good imagination, and a pile of junk.'

<small>Thomas Edison</small>

Here be treasure! When pirates see this on a map, they know they're on to something; that same euphoric feeling emerges when I happen upon old fabrics in need of resurrection into new work. I appreciate the sentiment in the Thomas Edison quote, but I never refer to my 'thrashed threads' as junk. If you, like me, are powerless to resist the magnetic pull of found materials, here are a few thoughts on how to incorporate them into your work.

Matters Material

To wash or not to wash, that is the question. I often buy vintage fabrics that are very inexpensive because the vendor is selling them as unlaundered and 'stinky'. Some smells are so pervasive they require several rinse cycles of a washing machine to clear, but not all the fabrics are robust or colourfast enough to machine wash. I'll air on the washing line first before I even consider washing, allowing multiple rain washes before handling again. This method is mostly applicable to the large, plain, hard-to-launder materials I use as backgrounds and padding for quilted work, such as old sheets and blankets. Fragile, embroidered decorative pieces will require more sensitive handling, and may well be too delicate to hang at all.

Above: *'Slaves to the Wind' (Deena Beverley), detail.*

Below: *Nelson's ensign.*
Antique found silk with
hand-embroidered and
quilted additions.
Bottom: *Hand-drawn*
and painted sun.

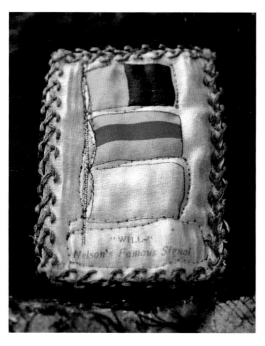

Sunshine: Friend and Foe

Sunshine is fabric's frenemy. Used judiciously, it can effortlessly bleach away rust, tea and mystery marks. That said, its strength must be used with caution, for it also weakens fibres and removes colour surprisingly quickly. So if you're sun bleaching fabrics, keep an eye on them. If I'm using sunlight as a stain remover, for an isolated mark on a snowy white linen tablecloth with an embroidered border for example, I will mask the embroidery and check it every half hour, removing it from strong sunlight as soon as the stain has lifted. High thread-count linen is much more robust than cotton, and both are stronger than silk in what they will tolerate in terms of sun bleaching and other cleaning methods.

Found Fabrics: New life for Old Cloth, and More

Integrating found fabrics and materials in my work has been a core part of my practice since childhood: I made my first mixed-media piece in a *Twinkle* comic with my mum's help when I was six years old, and my methods have changed very little since. I work quickly, decisively and intuitively, and I encourage my students to do the same. If you overthink this kind of collaged work, it becomes something entirely different; more static, like the decorative fabric appliqués placed in isolation on commercial clothing and home-décor items. There's nothing intrinsically wrong with that, but it's a very different approach to the richly layered possibilities of textile collage.

My advice here is simply to play. Cut, tear, rip, place, paste (if you like to use paste), stitch. Use iron-on, non-woven fusible webbing to stabilize or secure pieces if you choose to; I don't like the flatness of this approach, but it certainly has its uses and is an undeniably popular choice. Enjoy the process: move pieces about before securing or embellishing them with stitch, but keep it light, enjoyable and loose.

The Meditative Joy of Simple, Rhythmic Stitch

Deena Beverley

Kantha is an ancient Indian tradition of stitching rags together to make new, quilted cloth. Rooted in thrift, it's imbued with layered symbolic and spiritual meaning around 'making whole', 'the kind needle' and learning to tolerate life's sharp pain, like a misplaced needle's unexpected stab, to better accept more profound suffering. The term 'kantha' now generally refers both to the stitching style, and the resulting cloth.

Working kantha-inspired pieces in rhythmic running stitch is a deeply meditative process. Work meticulously, following or creating particular shapes, or in a more relaxed way, when conversation and companionship are more important than perfectly placed, even stitches. For me, kantha turns rags into soulful riches; creating meaningful new textiles from discards.

Kantha Cowboy

I made my 'Kantha Cowboy' wholecloth quilt literally from rags, joined using running stitch. I found the polka-dot bandana in the gutter, covered in mud. I tweaked kantha stitch methodology by joining areas using French knots, like tiny mattress tufting points, punctuating the polka dots. A torn 1950s handkerchief yielded the cowboy image.

The more heavily stitched the surface, the more satisfyingly quilted kantha becomes; but resist stitching rows so closely you lose kantha's natural undulations. Kantha's beauty appears spontaneously, in the gaps between the stitched rows; like 'life happening while you're busy making other plans' (paraphrasing John Lennon). Enhance kantha's rich depth thus:

- Stitch rows in opposing directions, creating dynamic tension for rippling movement.
- Gently pull on your thread, slightly gathering the fabric as you work, creating a sense of motion.
- Stitch in classical kantha patterns: e.g. *butti* (stand-alone individually placed spiral and star motifs).
- For *bejod* (misaligned) stitching, work parallel rows of running stitch without placing stitches in the first row in direct relation to those in subsequent rows.
- For *jod* (aligned) rows, place stitches in subsequent rows exactly under those in the first row.

Top: *'Kantha Cowboy'*
(Deena Beverley). French knot polka dot quilting.
Above: *'Kantha Cowboy'*
(Deena Beverley). Classical kantha running stitch enhances the sense of movement in the lasso.

Respect for the Material: Rhythmic Stitch

'You cut a length of thread, knot one end, pull the other end through the eye of a needle. You take a piece of fabric and push your needle into one side of the cloth, then pull it out until it reaches the knot. You leave a space. You push the needle back through the fabric and pull it out on the other side. You continue until you have made a line, or a curve, or a wave of stitches. That is all there is: thread, needle, fabric and the patterns the thread makes. This is sewing.'

FROM *THREADS OF LIFE*, CLARE HUNTER 2019

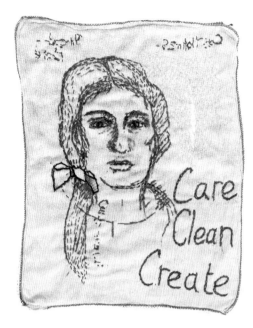

Above: *'Care-Worn' (Cas Holmes). Featuring my great grandmother, this is a contribution to Vanessa Marr's Domestic Dusters project (see page 92–93). It is a response to my struggle to balance domestic responsibilities with work in what I refer to as the Care-Clean-Create balance.*

Cas Holmes

Coming from a place of improvisation, the act of stitching plays a leading role in the creation of my work. I enjoy the haptic qualities of the cloth as I slowly draw salvaged remnants of past projects and found materials together, using a combination of simple machine- and hand-embroidery techniques to create richly worked 'new' pieces. This process carries echoes of the Japanese principle of *mottainai* – respect for the material and a regret for anything that has to be wasted – and of *boro* (*boromono* means 'rags' in Japanese and refers to clothing and textiles that are repeatedly patched and mended with simple straight stitch to extend their lifespan; an example of vintage *boro* can be seen in a collection of personal artefacts in the image on page 7).

Treasured vintage threads are collected in small bags and baskets. Individual strands are extracted from the glorious kaleidoscope of tangled texture and colour as required. Bringing these discordant and often overlooked pieces of cloth and thread together with stitches is part of the process of repair.

The act of sewing requires few tools, yet the needle in the hands of the embroiderer is a tool capable of creating artworks of great complexity, expression and form.

Below: *Detail of 'Emakimono' (Cas Holmes), with print patterns based on Japanese garden imagery (work featured on page 73).*

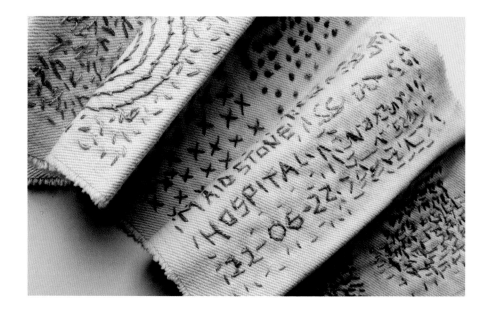

Left: *Stitch sampler (Cas Holmes). The sampler is marked out in a grid in which different embroidery techniques are applied. Each section explores changes of scale, direction and dimension as it is worked in stitch. The 'unconscious marks' that result from working from both sides of the cloth create more interesting textures and movement in the stitch patterns.*

Stitch Sampling: A Collaboration between Deena Beverley and Cas Holmes

Discussing this collaborative sampler project, Cas showed me one produced during her partner's hospitalization following a stroke. Patterns include voided circular shapes later appearing in her larger scale pieces, illustrating how simple marks made on samplers can feed into more evolved work.

Cas recalls, 'Recovering from the stroke's impact, it was evident the "large holes in Derek's brain", as he referred to lost brain function, profoundly impacted his body, including loss of mobility, vision and sense of touch. I filled waiting time preparing a sampler for a class, using fabric from Derek's threadbare jeans. This carved out a calm space amidst a hospital ward's cacophony. Gaps and spaces started to appear in the stitching as I worked from both sides of the cloth. The sampler marked our time waiting, each stitch like a counter.'

In classic sampler style, Cas stitched the date and location of where she worked her embroidery: the hospital where her partner was treated. Asemic writing (writing not immediately legible to the viewer) forms on the surface by text worked from the sampler's reverse.

Entrusted with this precious artefact for photography, I literally held a stitched fragment of Cas and Derek's life in my hands. These apparently simple samplers are actually potent pieces. You may be surprised to discover just how much they mean to you as you work these seemingly humble cloths.

Creating a sampler to sit companionably alongside Cas's piece, but speaking to my own experience, I related my palette to Cas's subdued sampler, echoing the dark nature of what she'd gone through while embroidering it, and mindful that these pieces would sit together here and in exhibition.

In keeping with the use of worn clothing as a background I chose vintage shirt collars as individual book volumes on which to mount my samplers of hand stitch

worked on fabric scraps from old blouses. Experiencing my own challenging personal circumstances, with limited access to time, materials and energy, I took these items on what I knew would have to be a working holiday, given this book's deadline was looming.

My compromised mobility, balance, fatigue, pain and anxiety about situations beyond my control at this time, were highly problematic. I felt frustrated and constrained. Sitting in the car on the seafront, unable to comfortably walk the few steps to the beach, I watched gulls soaring overhead, envying their free roaming ability. I sketched their powerful lines in instinctive embroidery, enjoying the mindful focus of challenging myself to use only straight stitches.

As the gulls approached our car in hope of Cornish pasty discards, I recorded their distinctive footprints in straight stitches.

I also immortalized limpets and seaweed in simple stitch. French knots, some with extended, comet-like tails (pistil stitch), and cross stitch using different stitch lengths, were worked in the same weight of thread; all I'd been able to hurriedly access. I varied the stitch's visual weight, emulating a drawn pencil line, by doubling up one strand; making closely parallel repeated stitches to emphasize, for example, the shadow in a limpet shell's lee. Notating these minute details in embroidered form, my mind stilled and my spirits lifted; the simple power of stitch sampling.

Creating a stitch sampler

- Explore different approaches; vary stitch length, direction, colour, thickness and texture.
- Seek patterns, colours and textures in the existing found cloth and use them to inform your composition.
- Work from both sides of the cloth: sometimes the 'unconscious marks' that result from the process can create more interesting textures and movement in the work.
- Remove, restructure, repair and rework: cut or tear a piece away from the cloth and add it back to another place; draw threads out of more open weave pieces, or cut more holes to extend a lacy pattern.

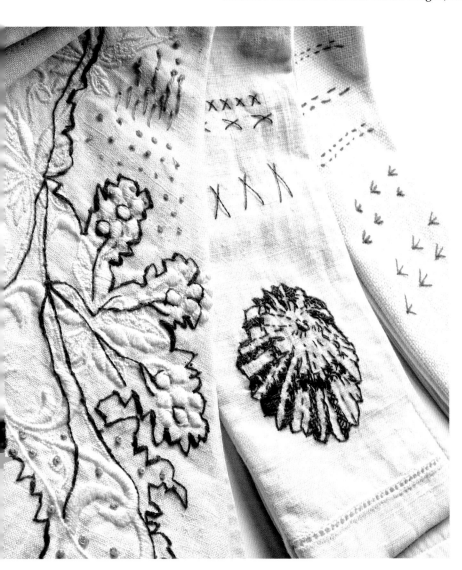

Below: *Seaweed, seagulls, shells and shirt collars. Stitch sampler (Deena Beverley). Hand embroidery on vintage cotton shirt collars and damask tablecloth fragments, found threads and fastenings.*

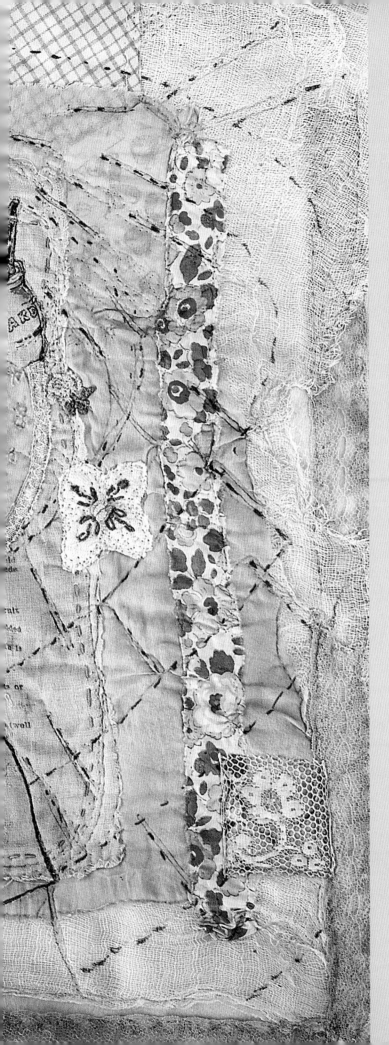

CHAPTER 2

Pockets

Left: *'Four Corners'
(Deena Beverley). Hand-
drawn, painted and
embroidered on pieced
and patched found fabrics.
Ink and watercolour on
vintage cotton and linen.*

Pockets

Few of us feel we have enough time, energy, stamina or resources to do the things we would like to be able, or even need, to do. Pulled in myriad directions by multiple demands, life sometimes seems to be a race we not only can never win, but in which we struggle to even participate. Fear not. Taking an approach that owes much to the 'spoon theory' metaphor that helps people with chronic illness and disability plan their time, you can remain creative even when the odds are stacked against you, and find pleasure and calm by taking tiny pockets of time to reconnect with your creative core.

Deena Beverley

It's good news that great things can be achieved even in small windows of time, because that's pretty much all I ever have. Like most parents, I learned the imperfect art of spreading myself too thinly across a diversity of tasks when my daughter was born, three decades ago. I began to rebuild my career having spent four months of the pregnancy in hospital on enforced bedrest, followed by a month anxiously hoping my premature newborn would be well enough to leave the Special Care Baby Unit (SCBU).

In the pockets of time that I felt able to pick up a needle, I stitched quilts to donate to the SCBU, having myself found great comfort from the unseen hands that had given the quilts and tiny garments that now warmed my (very) little one. People had taken precious time to comfort people they would never meet, and that warmed my heart and encouraged me to do the same.

I was raised in a family that always did as much hands-on community work as possible, an ethos I continued with my daughter as she grew up. As the cultural anthropologist Margaret Mead said, 'Never doubt that a small group of thoughtful, committed citizens can change the world; indeed, it's the only thing that ever has.' Great things really do emerge from the smallest pockets of time, energy and ability, and with the most limited of resources. If you find yourself bemoaning the lack of any one of these, just pause, take a breath. Dig not deeply, but lightly. You have more available to you than you know.

The pieces I've made when I've really been up against it in every way are so often my most authentic, and to me my strongest work. Perhaps that's because the real and present pressures crush my near omnipresent self-pressurizing. Value and use those precious pockets. What can be achieved in them will surprise you.

'To achieve great things, two things are needed; a plan, and not quite enough time.'

Leonard Bernstein

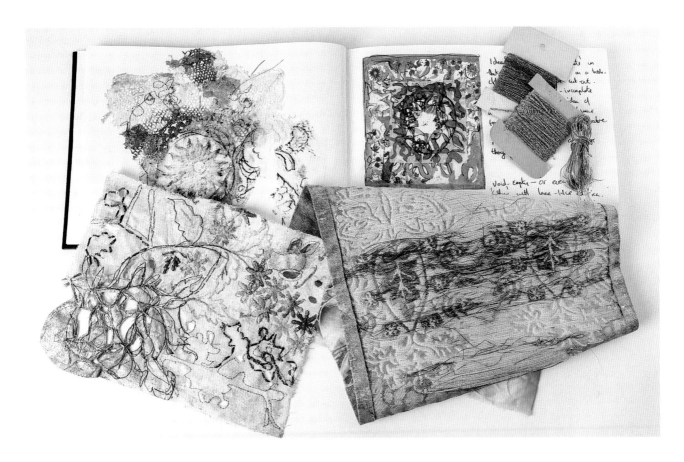

Cas Holmes

I work in the spaces 'in-between' other things, seizing opportunities during both day and evening to create, while undertaking the daily tasks as part of my caring role, or tackling the endless list of jobs that need doing around the house and garden. Portable kits for drawing and stitching have kept me occupied during countless doctor and hospital visits, on rail journeys, or at the various spots where I like to sit and take a break during the day at home. These kits contain the bare minimum: a few favourite brushes inherited from my father, a miniature watercolour palette and drawing implements in a folded cloth wallet, partnered with a vintage silk bag from Japan containing a jumble of threads, needles and scissors, ready to pick up at a moment's notice to put in my rucksack.

It is these jewelled moments of quiet reflection – taking time to sit and draw, or to stitch on smaller samples – that bring calm to a busy day and give birth to ideas for new projects. This is as important for Derek to see as it is for me to experience, a recognition that some parts of our lives, though changed, can continue, and that a part of me, the artist and teacher, can still practise. These restrictions on my movement and time have taught me to adapt and learn as a maker, an innate human drive to seek out new pathways, to connect and to grow, irrespective of the challenges we face.

Above: *Sketchbook and samples. The reverse of the gold brocade Japanese Obi cloth provided the inspiration for the application of gold foil in Repair (see page 45). I sit and stitch the samples at the quieter times in the evenings.*

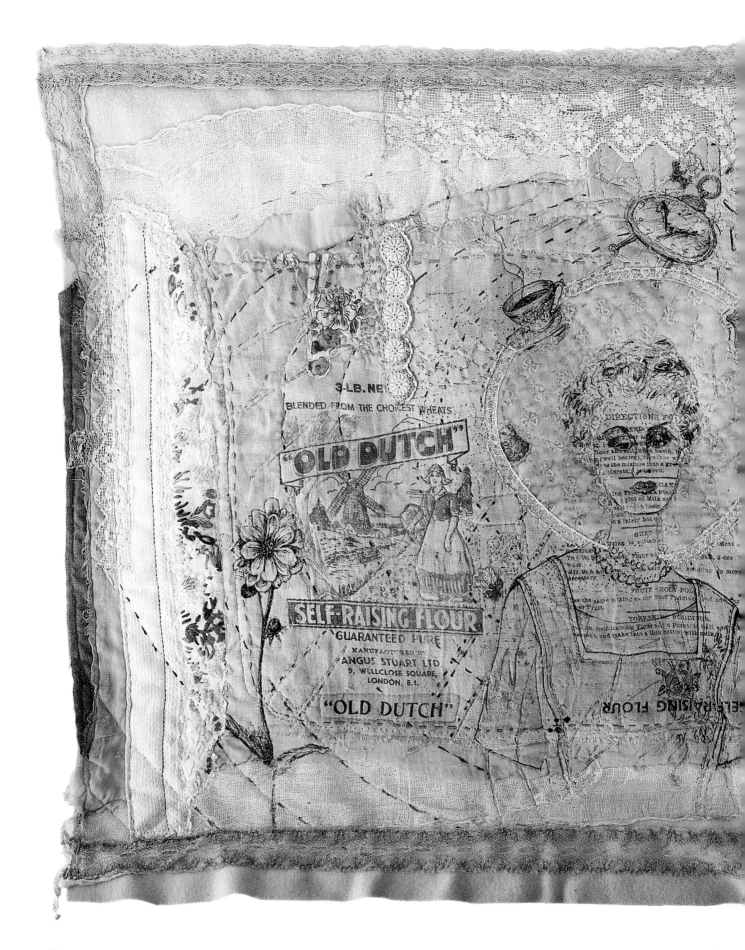

Four Corners

Deena Beverley

In my rural childhood, only fathers had cars and few mothers worked outside the home. Domestic goddesses still both ruled and feathered the roost. At school, our archaic domestic science textbooks purveyed domestic perfection as the pinnacle of feminine achievement. One book memorably advised: 'Apply fresh lipstick to greet your husband home from work. He does not wish to see you careworn. Exchange your overall for a frilled apron and pretty frock.'

I had no intention of devoting my adult life to domestic drudgery. After art school, I built a career that developed beyond married life and motherhood. Decades later, however, in recent times, circumstances meant I unexpectedly migrated into a life of dramatically increased domesticity, producing meals and serving drinks to a strict timetable. (In this piece, the images spinning around the figure's head indicate the omnipresent repetitive tasks.)

I forced myself to devote brief pockets of time daily to producing new work. This piece, one of three from this period, proved surprisingly cathartic. My starting point was a vintage 'Old Dutch' flour bag; honouring links between my Norfolk homeland and the Netherlands, and referencing the sudden emphasis on hearth and home. Baking bread became both necessity and luxury; with bread, flour and yeast scant.

Confined to home, I started each day outside, compiling a handwritten to-do list. I didn't allow myself my phone and its stressful distractions, so didn't have my camera. Longing to record the flowers around me, I sketched them on the back of my lists and whatever was to hand, including found fabrics. The dahlia drawing celebrates a plant I'd bought myself to cheerlead me through challenging days measured out in cups of tea and relentless domestic routine, feeling overwhelmed.

When I sketched the domestic goddess encircled by a doily halo, I had no idea who she'd turn out to be. Inspired by an illustration on an old dressmaking pattern for the kind of decorative apron my school textbook instructed women to wear, I imagined my goddess would appear serene; her life untroubled by having to carve out a career or provide the family income. I was surprised when she revealed herself to be much more imperious than I had planned. Perhaps domestic goddesses really are the queens of the hearth after all.

Left: *'Four Corners'
(Deena Beverley). This
cherished 'Old Dutch' flour
bag found its forever home
in this piece.*

Faux Chintz Broderie Perse with Found Fabrics and Original Imagery

Deena Beverley

Found fabrics bring colour and inspiration, tactile pleasure, and their own held narrative to my work. I handle, edit and curate them daily in the constantly shifting micro 'textile museum for myself' they represent. I also create my own imagery through sketching on them, a core part of my daily practice squeezed into small pockets of available time.

Maximizing precious time I've taken to draw and paint original imagery, by including replicated versions of it in new work, is simple, using various image transfer methods. A method I often use is the same acrylic transfer method Cas describes on page 25, which can be used with diverse fluid transfer media, including household emulsion paint. I use whatever's to hand; here, glossy Mod Podge left over from a commissioned piece.

I'd usually choose a matt finish for personal work but serendipity is a marvellous thing. The gloss resembled beautiful glazed chintz vintage fabrics from my collection, so blended seamlessly with older pieces, as Broderie Perse.

Broderie Perse (Persian Embroidery) was a fabric decoupage technique popular from the 17th to 19th century, maximizing expensive chintz fabrics by applying cutout motifs to plain backgrounds. In these frugal times, when thrift and reuse of materials are key, Broderie Perse remains relevant. It's also a great way of incorporating motifs holding special memories into new work.

You could use a tiny amount of a pictorial print bought as a remnant, or a page from a sample book as a central feature in a new piece, extending the motif using embroidery, additional appliqué, painting and drawing. With Broderie Perse, a little goes a long way.

Imagery for Broderie Perse

Besides a background of your choice, you'll need textile or paper with large, easy to cut motifs and/or your own imagery, reproduced and transferred by your preferred method.

I prefer an age-softened, degraded look to a crisp, accurate rendition of the original, so I photographed a detail of 'Four Corners' to use as a Broderie Perse motif. Using my phone, I photographed the dahlia I'd drawn, then stitched

Below: *The tiniest precious scraps of found fabrics, for example from cherished outgrown or worn-out garments, discover new life as informal Broderie Perse motifs.*

Above: *An original plein air botanical ink drawing on irreplaceable antique fabrics acquires additional life when photographed and translated into faux chintz Broderie Perse motifs (see previous page).*

into on an old flour bag, before printing this photograph on basic inkjet copier paper. Using the acrylic transfer method with glossy Mod Podge produced my own 'fabric'. The glazed faux chintz motif was by now very visually softened, having been through multiple stages; additionally muted by the inherent murkiness of inkjet printing.

Cut around your motifs, ready to add to layered found fabrics and papers using your preferred methods of attachment.

Methods of Attachment

Although iron-on, non-woven fusible webbing is a popular, practical choice for Broderie Perse, it's not my chosen method. The 'handle' of the vintage fabrics and papers I collect is crucial to me, and I prefer to attach my motifs using free-motion embroidery and hand stitch.

When adding transferred acrylic imagery, any stitch holes you make in it are permanent: essentially, you're working with a material akin to paper or card, so think carefully before puncturing with a needle – although needle holes in themselves can be visually striking decorative marks.

The fun part comes when you begin to merge or separate your motifs from the background using whatever you have to hand in the moment. I had some Inktense pencils on my kitchen windowsill, so coloured my floral motif with these; I then stitched over it with threads that happened to be in my pocket, as I'd just won them in a raffle.

Stitch Suggestions

Vintage threads combine beautifully with found fabric stitch. Sometimes insufficiently robust for use in other projects, they are far too lovely to sit in a drawer, unloved and unappreciated. Use short lengths to reduce pressure on the thread as it passes repeatedly through your work, to reduce the risk of breakage. Regularly invert your work and allow your threaded needle to drop so that the thread unwinds from the twist that forms as you stitch, to help retain strength in the thread and avoid tangles.

Use stitch to merge motifs old and new with each other and the background. Here, my embroidery in vintage brown silk travels to the edges of my Broderie Perse faux chintz dahlia, before merging with the vintage bird branch embroidered and painted by an unseen hand long ago.

Decide whether to run some areas together or crisply delineate. Here, I've chosen to run my stitching from the vintage orange chiffon flower straight through to my dahlia image, rather than defining the dahlia's edge, despite it being the more dominant motif.

Be free with this process. Don't overthink it. I'll pick it up and play with it here and there, every stitch a precious pocket of relaxation and recreation in a busy, overwhelming day.

Repair

Cas Holmes

I had been given a beautifully worked tablecloth, covered with trailing leaves and bright satin-stitched flowers. The unknown hands that originally embroidered the floral details had stopped part way through, leaving the work unfinished. Mysteriously, a large piece had been removed from the centre, leaving a circular hole.

This damaged tablecloth, a quiet reminder of times spent gathering around a table with family and friends, was destined to be torn up and reused. I wanted to honour and respect the work of the original maker as part of my process of 'repair'.

For a long time, the tablecloth was placed in my studio window to serve as protection against the sun. Looking through the cloth into the garden beyond brought back memories of walking through a Japanese moon gate in a Kyoto garden. Conversations ensued with Deena, prompted by her seeing a moon gate while travelling, about how this simple round opening in a wall represents the threshold, or a portal between two worlds, and the act of passing through the gate into another place is symbolic of transition and renewal. This damaged cloth went through several design iterations before I was satisfied, and it became a metaphor for my own transition and adaptation to change.

I worked on the tablecloth over the winter evenings, repairing and extending the original embroidered floral design with hand stitching in gold and green threads. The reparation of the 'breaks' in the worn cloth gradually morphed into strange flora-like patterns similar to those I had seen on brain scans.

A lighter-weight silk voile panel inserted in the centre partially closes the hole, onto which I continued to follow the lines of embroidery with free-motion machine stitch. Sections were cut away to leave a lace-like repair, partially filling the space. Foil from discarded cigarette packets and chocolate wrappers proved a good substitute for gold leaf in some of the sections of this newly worked cloth.

The piece hangs so it casts circular flora shadows onto the wall behind. The gold overlaying the damage will never make the hole 'whole' and is symbolic of emotional repair, beauty and strength.

Right: 'Repair' (Cas Holmes) started during Derek's second long stay in hospital. Hand stitch, gold foil, machine stitch and cut outs. 85 x 85cm (33 x 33in).

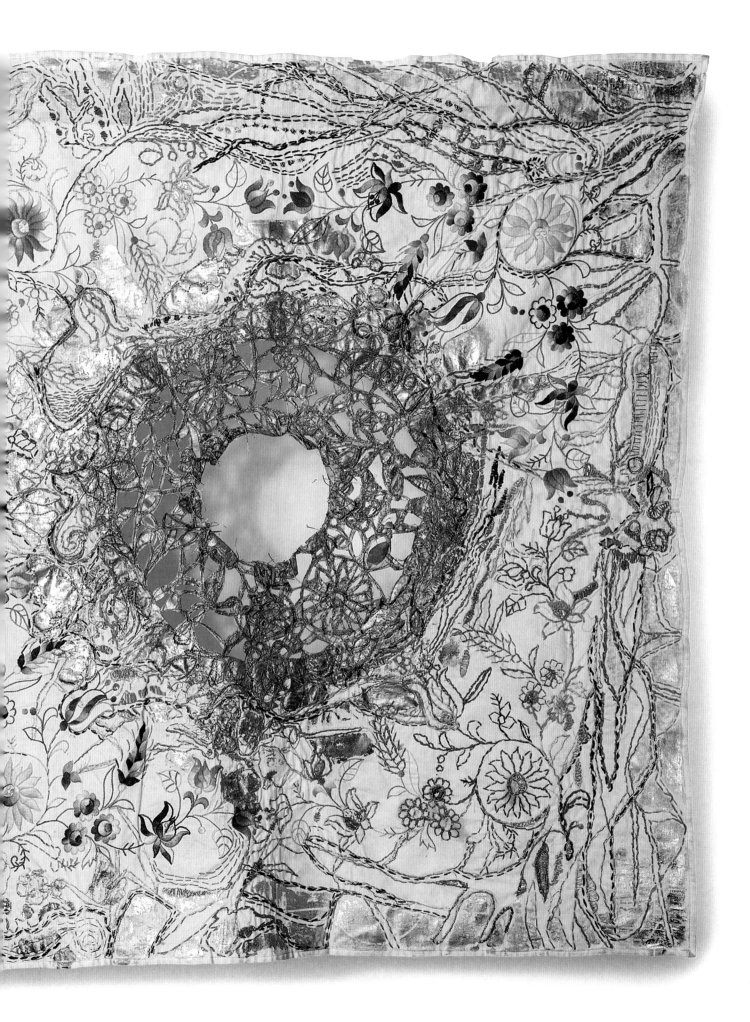

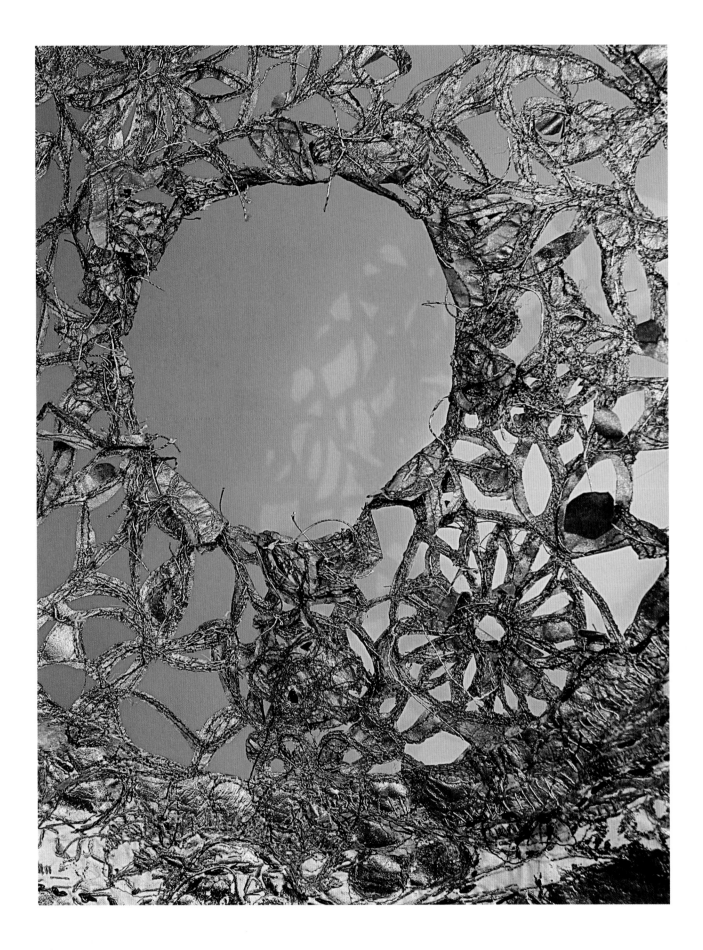

The Value of Repair

Cas Holmes

Opposite: Detail of the central section of 'Repair' (Cas Holmes), showing the transferred foil and the cut-outs casting shadows behind.

Culturally and historically, valued objects in everyday use were repaired when damaged or worn. I remember with fondness the mended pots and pans we often used when baking in my grandmother's house as children. Artists and makers today, through the practice of mending, are laying the groundwork for new ways of thinking about the objects we surround ourselves with.

In Japan, broken ceramics are repaired with a precious metal such as gold or lacquer in the art of *kintsugi* (golden joinery); and precious old cloth is patched together with stitching in *boro* to create beautiful, unique pieces. The repair process is part of the history of the object, so rather than trying to disguise the damage, it is integrated into the repair and transformed. The marks or repairs may be evident, but they are now regarded as part of the beauty of the object.

To apply foil to my work, I use good-quality non-waterproof PVA glue or acrylic gel/matt medium and apply it onto the areas I want the foil to stick to. In 'Repair', I worked it into some of the spaces between the areas of embroidery to emphasize the central area and the edge of the cloth with the gold. Experiment with different methods of applying the glue to the cloth, such as writing with a glue pen or stencilling a pattern onto the cloth with the glue.

Below: Ironing using factory waste foil into the background spaces of the tablecloth used in 'Repair'.

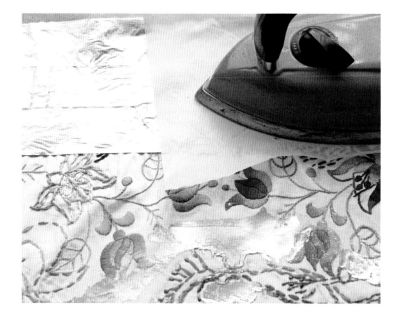

Foil Transfer Technique

1 Apply glue or your chosen medium with a brush or use blocks and stencils to print patterns on the areas of the cloth where you want to attach the foil.

2 Wait until the medium is slightly tacky or dry to the touch, before placing the foil, shiny side up, onto the fabric.

3 Sandwich the cloth, with the foil patches in place, between sheets of baking parchment, to protect your iron.

4 Press with a medium iron (I usually set mine to a wool or cotton setting and adjust as I need to) and iron firmly for approximately 20–50 seconds.

5 Allow to cool, then peel off the excess foil.

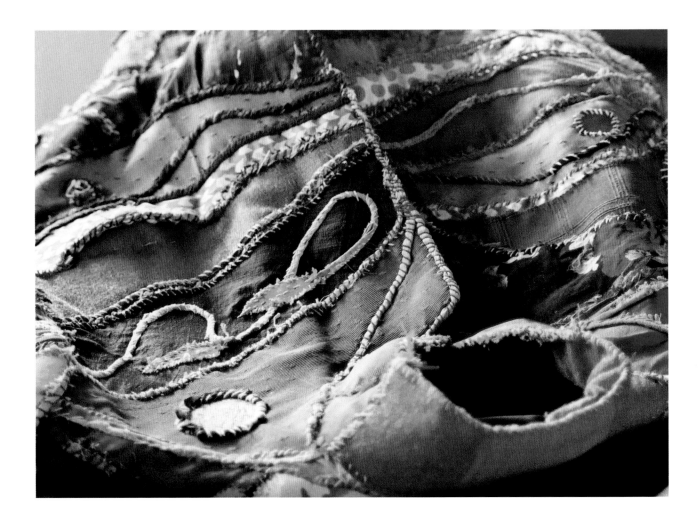

Jake Annetts: The Thread Man

Deena Beverley

When a raging bushfire destroyed what Jake Annetts and his partner had spent years building and growing from scratch, only the very smallest pockets of time and energy were available for anything remotely approaching relaxation. A major, ongoing regeneration of the land and their home occupied almost every waking moment. However, along the way, Jake discovered the therapeutic power of simple hand stitch to soothe and console in the extreme emotional and physical landscape he was forced to navigate. He shared his story and images of his beautiful hand-appliquéd jacket online in social media groups related to fabric recycling, which is where we 'met'.

We bonded over a shared passion for the healing power of working in simple ways with found cloth, appreciating its tactile appeal as well as its ecological and thrifty attributes. We both also value its considerable power to connect people whether in person or online;

Above and opposite, top: *Hand pieced, hand embroidered found fabrics (Jake Annetts).*

after all, that's what brought Jake's story, as a textile artist in rural Australia, to me, a textile artist in rural England:

'My journey with sewing began in the 1970s when, as a biker, I would create patches and stitch up my jeans and jackets. I had an embroidered patch which I'd started when I was around 19, but it was never completed and was stashed away in a box of treasures, locked away for almost 40 years.

'In 2019, devastating bushfires swept across Australia and we lost our farm and home. Shortly after, the world went into COVID lockdown, and it was then I rediscovered the old patch and had an urge to finish what I'd started all those years ago. It reignited my love of textiles and I spent my days and nights creating new embroideries to pass the time, healing and recovering from the trauma of losing almost everything we owned.

'The embroideries led me to creating a hand-stitched jacket with appliquéd patches and from there I had an urge to try my hand at weaving. I was hooked, and my "Thread Man" online identity was born.

'I've always had a leaning towards upcycling and, as a trained furniture maker, I often created pieces from recycled timber and antique trimming, so working with upcycled fabrics was a natural progression. The earth is drowning in fast fashion, so to be able to take a garment that would normally end up in landfill, and reuse pieces of it, is not only satisfying, but ties into my philosophy of living sustainably. Taking a strip of delicious, preloved fabric and stitching it on to a jacket, or weaving it to form new cloth which can form the basis of a garment, is very rewarding.

'I'm always looking for new ways to reuse old fabrics and have started making appliquéd and woven bags, jackets, jeans, and, more recently, unique customized spirit dolls. I'm not sure what my next creation will be, but I know my love of creating using found fabrics will never stop.'

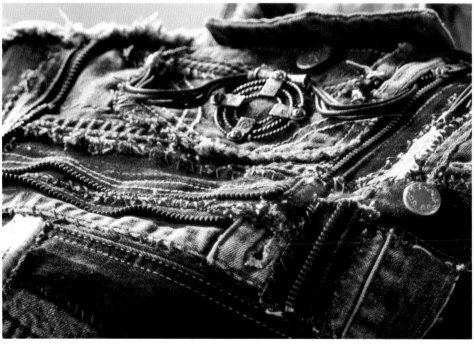

Left: *Patched and pieced found denim and embellishments (Jake Annetts).*

49

Mair Edwards: Forgetting and Remembering

Deena Beverley

The ethereal nature of Mair Edwards' work belies the intensity of what was going on in her life when she began to create exquisitely realized pieces in, as she describes, 'fabrics mostly transparent and delicate, creating shadows that can evoke transient and intangible memories.'

'My mother had begun to lose her memory and this influenced my work at the time, which explored some ways that memory can be lost. Remembering and forgetting are intrinsically linked. Memory is what makes us who we are. The loss of our memories can cause the disintegration of our personalities and our meaningful lives.'

Mair began to remember and record stories and events in her and her family's lives, as she explains:

'Fragments of remembered memories awoke half-forgotten associations, as our past lives on but only in memories...[seemingly] insignificant objects and memories of daily life unlocked half-remembered stories, inspiring my embroideries. We keep our loved ones alive by remembering life's stories and events.'

Inspired by her own family tree, Mair relates how the poem 'I am Not Alone' by Welsh Poet Laureate Gwyn Thomas also influenced this work, speaking, she says, 'of "the faint breathing of many generations of my ancestors" and how we are all part of that continuum of family and mankind'.

My Childhood Sundays

Recalling Mair's childhood in Wales, this piece describes how much 'life has changed...the saying "the past is another country" rings true'. Sunday especially was markedly different, with no shops, pubs or buses, 'just chapel and family'; Mair and her sister 'in our Sunday best: matching coats, gloves and round felt hats'. Mair reproduced the distinctive child's coat in

Below: *'My Childhood Sundays'. Found paper, cotton organdie and thread.*

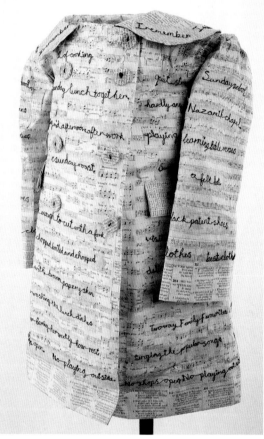

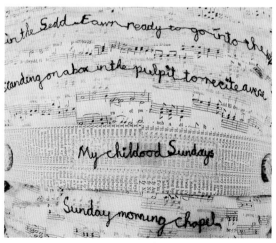

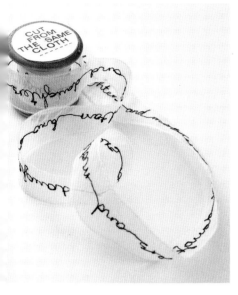

Above: *'Cut from the Same Cloth', three-dimensional embroidered cotton organdie.*

Below: *'Bloodlines', mixed media: reproduced Carte Postale photographs with free-motion embroidery additions.*

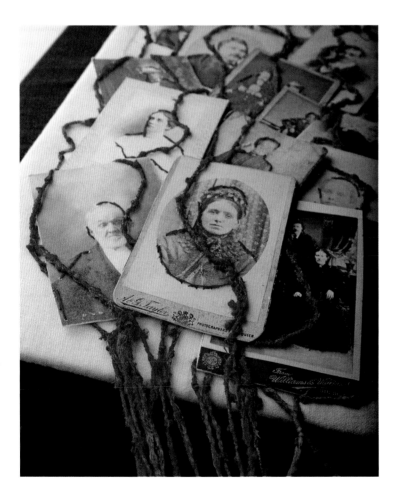

paper, using a disintegrating old Welsh hymn book as 'fabric', surmounted with free machine-embroidered memories on cotton organdie, worked separately then applied as slips. These include 'Sunday roast, visiting for tea and standing on a box in the chapel pulpit reciting a learned verse'. Circling the hem are Mair's memories of things notably different in her childhood to the current day: 'no shops open, no buses, no playing outside or getting dirty'. Text around the collar underlines Mair's appreciation of her ability to access these still-vivid memories, reading, 'I remember, I remember...'

Cut from the Same Cloth

One of Mair's mother's many sayings was 'cut from the same cloth', referring, she says, 'to someone she'd known a long time'. In 'Cut from the Same Cloth', Mair says, to illustrate 'we are only part of the story, the (embroidered) fabric roll at the top shows the generations that have been, while the (blank) fabric roll at the bottom is ready for those still to come'.

Bloodlines

Mair continued the series with work using family photographs scanned onto photo paper from originals on postcards 'too difficult to sew through easily', connected by free-motion embroidery cords representing 'the bloodline that connects us'. Some, such as her grandparents, Mair knew personally, but although all were relatives, she does not know all their names. This powerful work acknowledges that, names remembered or not, 'They have all contributed with their DNA, and some very old family recollections, to the generations that are now...we are only part of the story.'

Souvenir
(Tea and Roses)

Deena Beverley

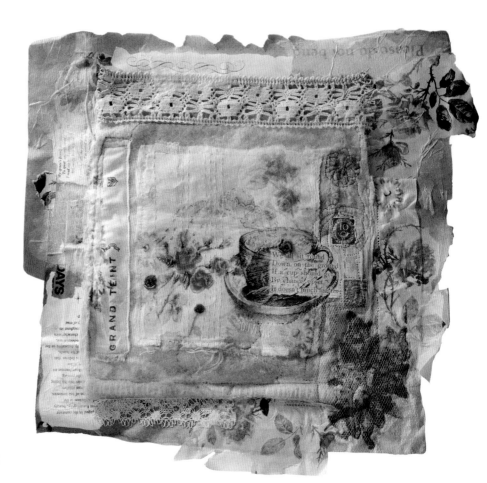

In junior school, tasked with a
summer project on any subject of
our choice, I selected tea, creating
a comprehensively researched
thesis, richly illustrated with the
mixed-media additions that have gripped my imagination ever since. Old paper
and ragged torn fabrics, on the point of disintegration, as fleetingly beautiful as
a blooming rose before its petals fall, these are my materials of choice, and they
seem to pile up around me wherever I am.

As a child in rural Norfolk with limited access to shops and money, using
whatever was to hand was a part of daily life. I used a homemade flour and
water paste to attach the many artefacts I gathered to my book, itself made
from recycled cardboard stitched together with a binding made from twine
purloined from my grandmother, a butcher accomplished in the art of knotting.
Repurposing was a way of life growing up in the late 1960s and early 1970s and
is now hard-wired in me. This has proved useful when making new work for
this book, with very limited access to my materials, tools and equipment.

'Tea and Roses' is a souvenir of when I had no time to smell the roses, yet
I still *made* time to smell, stitch, draw *and* prune them, the latter in a rather
haphazard way. Royal Horticultural Society trials show that if you prune roses
with an electric hedge-trimmer, they fare no worse than if you meticulously
hand cut them with secateurs; I like this metaphor, given that anything even
approaching perfectionism is a very long way out of reach, although I do
enjoy occasionally dipping into my repertoire of classical hand-embroidery
techniques, such as the plump bullion-stitch roses I embroidered here.

Above: *'Souvenir (Tea and
Roses)' by Deena Beverley.
Hand-drawn, painted and
embroidered on layered
found vintage fabrics,
using found threads.*

Opposite: *Details of
'Souvenir (Tea and Roses)'
by Deena Beverley.*

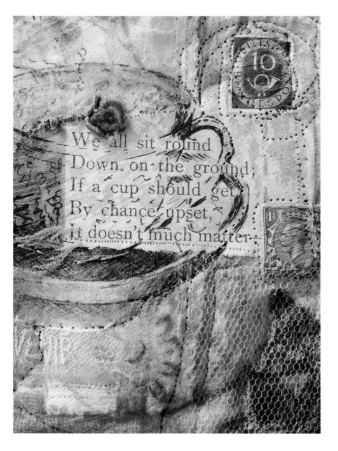

Tea and Roses: Mixed-Media Layering Technique

1 Work on a surface protected with plastic: you could use cling film or a carrier bag, but I prefer a heavy-duty bin bag, temporarily slipped over a chopping board, as it's robust and lays nicely flat, desirable if you're working with delicate fabrics and papers you don't want crumpled when your layers dry.

2 Gather materials that inspire you: don't overthink this – here, I've grabbed whatever's to hand, including the ephemera and haberdashery silt that accumulates on the floor in every corner of our tiny cottage. Post is a rich source of material; even junk mail works well when it's layered with other things, such as scraps of old torn scarves, old lace, discarded gift wrap and pages from wrecked books.

3 Add wallpaper paste granules to your water and mix to a thick consistency, somewhere approaching 'you can stand a spoon up in it' school dinner custard.

4 Working swiftly and intuitively, cut, rip and paste (imagine yourself doing 'messy play' at school). You can be liberal with the paste as it's very forgiving. Have wet wipes and kitchen paper to hand to clean up any spills, but really, it will all dry beautifully even though it looks a gooey, sloppy mess. You can endlessly reposition your pieces of paper and fabric while the paste is wet. Paste liberally on top of your pieces too, for additional security and stability.

5 Leave to dry completely before adding stitched embellishments of your choice by hand or machine, or both. I enjoyed adding simple hand-embroidered details to this piece, in homage to the roses that were my late mother's favourite flower, in vintage threads and on found fabrics that evoked a time when she was, like the flowers, at her most vibrantly, vivaciously alive.

Sketchbooks:
Carving Out Time to Focus

Cas Holmes

It comes as no surprise that we enjoy looking at sketchbooks. We're just so curious to have a glimpse into someone else's world.

Carving out a little dedicated time to sit and draw (or stitch) can be therapeutic and help you to focus and process your ideas. The sketchbook is my 'go-to' when I need to organize my thoughts, or just simply record my observations, and I have several on the go at once dotted around the house. The sketchbooks I use come in many shapes and forms, from the commercial to improvised books created from found papers and waste cardboard or cloth-based materials. The sketchbook becomes a personal journal or diary, and is the perfect place to record the things you explore, your ideas and techniques, as it holds everything together in one easily accessible place.

I was driven to use waste medication and related packaging as the basis for some of my improvised sketchbooks over the last few years. This visible connection to my daily routine creates the bridge between my roles as an artist and a carer, and reaffirms my thought processes as I record the things I am experiencing. The thoughts that run through my brain are made visible on the page, creating a dance in one direction before moving on into another.

Left: *Elements of medical packaging and contents have been used to provide some of the pages and to create fastenings in this selection of improvised sketchbooks.*

Opposite:
1 *A useful 'viewing device' can be seen in the sketchbook made from a mask box. The study of Hastings fishing boats was created on a rare respite day gifted by a close friend. The pages are held in place with a 'pamphlet' stitch for each section. I often use a simple running stitch or a straight machine stitch to hold pages in place.*

2 *This sketchbook is created out of a COVID testing kit. The study of the courtyard at West Dean College is a powerful reminder of the value I place on the interaction that takes place in a studio setting. Some of the pages were gifted to me by students on a course.*

3 *A medicine dosette box is used in the concertina sketchbook which incorporates medication wrappers into the printed and stitched plant studies. Gardening is my medicine.*

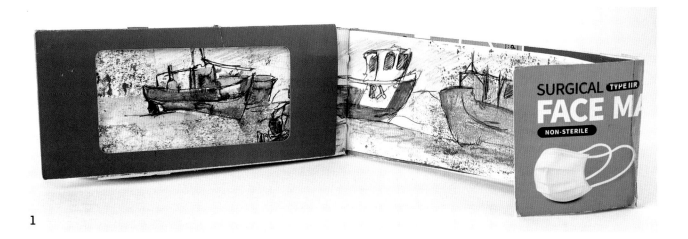

1

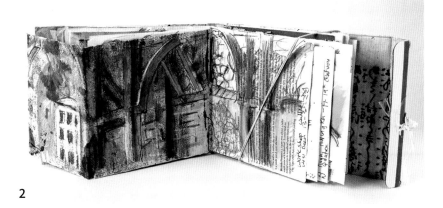

2

3

Creating your own sketchbooks by redeploying waste papers can remove the fear that a blank sketchbook page in a brand-new sketchbook can bring. Most of my improvised sketchbooks are created using simple folded sections, also referred to as signatures in book-binding terms, that are held into the cover at the centre of each double page with stitching.

In the examples shown here, the sketchbook covers have been made out of medical packaging; some pages fold outwards to extend the width of the drawing space; others are smaller, allowing a view of the underlying page. It is as if my sketches want to escape from the pressure of 'confinement'.

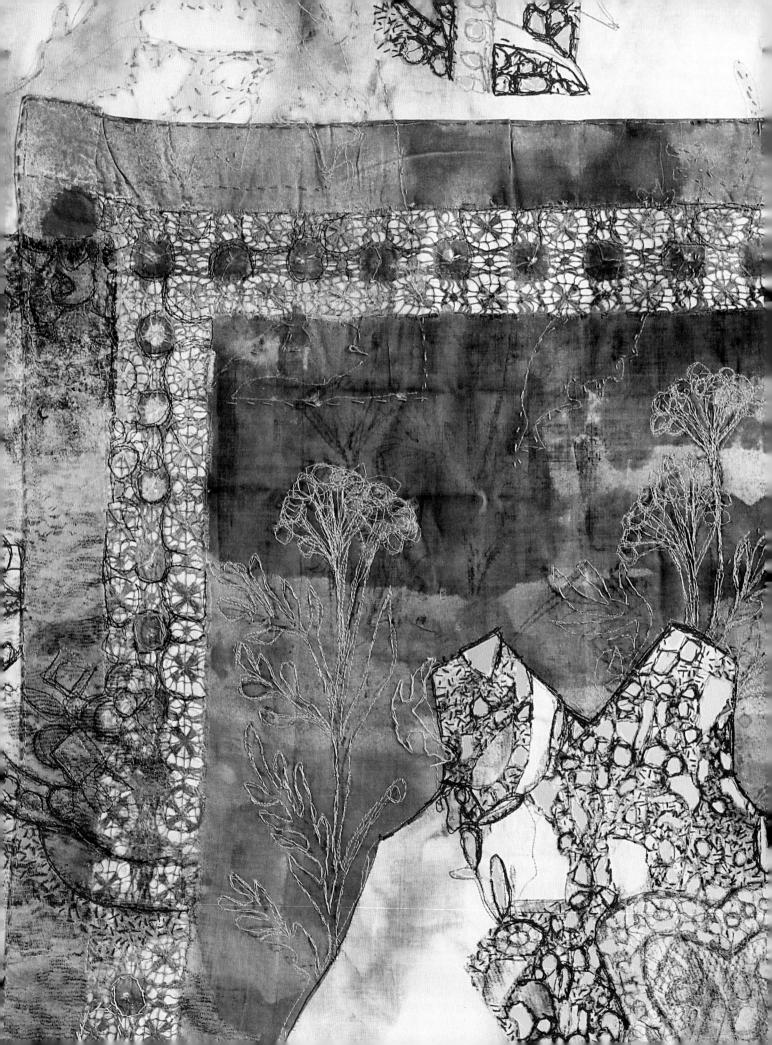

CHAPTER 3

Messaging

*Left: Detail of 'Memory'
(Cas Holmes). The shape
of a dress is seen on the
front of this piece and
echoed on the reverse of
this double-sided work.*

Messaging

Textiles have long been used to signal and signify messages, both personal and political. Banners, badges, flags and more, down the ages have communicated messages to the masses, and sometimes more quietly, in the case of coded messages, only intelligible to the few. Here, we explore the power of textiles to voice what is not always spoken aloud, or in public, whether that textile is made to be publicly shared or not. We talk to artists who use textiles as a messaging medium, and share our own use of textiles as communication.

Speaking My Truth

Deena Beverley

As an artist and author for whom words and textile art are inextricably intertwined – my textile pieces often featuring text, or inspired by text – at heart, most of my work is full of messages. Some are intended to be read easily by the viewer, others are buried a little deeper, requiring closer inspection and interpretation. It feels important to me to speak my truth in textile form, whether others see, read and interpret it as intended or not. Releasing it from my head, and sometimes heavy heart, through my hands into textile form is a means of catharsis and communication, irrespective of whether anyone is listening.

Unspoken, Truth and Silence

Cas Holmes

Late at night, when unable to settle, I read or listen to the World Service on the radio. The utterances of night-time voices help me to connect to the world at a time when my day-to-day life is more solitary in nature.

Found text and images often feature in my work. Collected papers, old books, magazines, packaging and letters carry their own references, which are part of our social and cultural inheritance. Legibility is not always a priority; the text and image are indistinct on the worn surfaces of the materials. Meanings are suggested rather than stated. In the cacophony of stimuli from everyday life, it can be difficult to take in the things we initially read, hear or experience, or to 'tune in' and focus closely. These pieces reflect the fragmentation of my 'unspoken' thoughts and feelings.

Left: *'For Emily' (Deena Beverley). Ink and embroidery on rescued materials. 'Hear me, see me', Emily silently implores, speaking for those unseen and unheard; then and now.*

For Emily

Deena Beverley

This stitched, painted tribute on vintage materials is dedicated to the suffragette Emily Wilding Davison (11 October 1872–8 June 1913). Embroidered and quilted on an antique satin ribbon rosette and crepe handkerchief, these materials reference the suffragette textile items it's thought Emily was trying to attach to the reins of the king's horse in the Derby race incident that killed her. One of the two flags she was carrying resides in the Houses of Parliament, where Emily famously hid overnight in order to ask the Prime Minister about votes for women.

The image is inspired by one of many cover images from *Punch* (1913) related to the suffragettes. Just as Emily's intentions on that day are ambiguous, *Punch* was not the unilaterally anti-feminist publication it's often believed to have been. Suffrage campaigner Millicent Garrett Fawcett, writing in 1922, described *Punch* staff as 'true and faithful friends of the women's movement'.

Although most recognized for the dramatic nature of her death, it is Emily's life that this piece celebrates, and her passionate assertion that: 'Through my humble work in this noblest of all causes I have come into a fullness of job and an interest in living which I never before experienced.'

Opposite: *'Unspoken' (Cas Holmes). Part of the faded text, transferred onto the cloth with emulsion paint, has been further embellished with machine and hand stitch. Thoughts that run in my head at night are often lost in the 'ether'. Each piece approx. 20cm (8in) square.*

Jo Smith: Tales of Love, Loss and Legacy

Deena Beverley

Below: *'Containers of Memories' (Jo Smith). Embroidered portraits of Jo Smith's mother as a child, as a young person, and in middle age, embroidered on copies of her death certificate.*

Meeting Jo Smith at the Knitting and Stitching Show where she was exhibiting as an Embroiderers' Guild Scholar, we connected through a multitude of shared enthusiasms, including vintage haberdashery, battered old dolls, and the need to 'rescue' things in danger of going to landfill, in order to give them new life. Moreover, we shared a highly emotional response to the held narrative in and around discarded objects, items once invested with time, energy and love. Jo was exhibiting 'Two Brothers, Three Sisters, and a Mouse', about the creatures buried in her garden and the manner of their passing. My husband Andrew, who took pictures of her work for this book, had recently exhibited his beautiful large format photograph of a dead mouse he'd found in our rented barn studio. The image polarized opinion. Some found it elegant and elegiac, appreciating his respectful commemoration of this small creature; to others, it was offensive, repellent in many ways.

Jo's work was similarly confusing. In 'Kitten Beds', a prettily embroidered suite of kittens permanently sleeping on charming miniature beds are, at first glance, sweetness itself, until the viewer notices the bugs which had led to the kittens' demise, stitched in unflinchingly large scale all around them. Her embroidered mouse portrait is initially appealing, super cute with his sparkling eyes and rosebud pink nose, until you notice the bones encircling him.

Here, Jo continues her heartfelt communication through exquisitely realized embroidery, in pieces that all have much to say beyond their initial striking visual impact.

Black Eye

Embroidery on a screen-printed image of actress Anne-Marie Duff (by photographer Rankin) from the 2007 Women's Aid campaign, 'What Will It Take?'. A banner connected with the Domestic Dusters project (see pages 92–93) states 'domestic is not a female word'. However, as embroidery is traditionally seen as women's work and the word 'domestic' is also tied inexplicably to women, it seemed fitting to Jo, as a woman making this work, to use a woman's 'domestic craft' – depicting a woman in a homely environment – to highlight domestic violence against women.

Red Collar

This piece, like 'Trust Me', was produced in response to Jo's research into FGM (female genital mutilation). Jo made the collar to fit a seven year old, having discovered that the average age for girls to be put through this horror was around eight. 'The lines on the collar for me express the blood spilt,' she says, and she made the collar a 'filthy, mucky looking colour to represent that this wasn't usually done in clean, sterile environments'; often the girls suffered infections and many died as a result. The small holes around the collar's neck band, only large enough to accept a fine twig, are the size of the opening left after FGM.

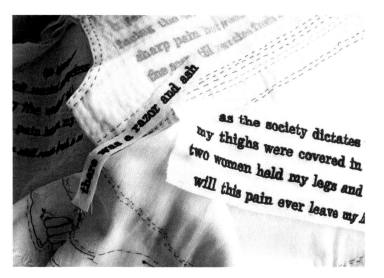

Trust Me

The dress has lines taken from actual accounts of FGM victims on its bib and is made to fit a child of around eight. The motif of a mother and daughter holding hands around the hem represents that, as Jo says, 'this awful act was approved by those children loved and trusted the most. Virtually all of these mothers had been victims of FMG themselves. It was passed on as a tradition.' The dress is layered and semi-transparent to represent, as she explains, 'the layers of tradition, expectation, and almost "hidden in plain sight-ness" of it; the awareness that it's happened and probably still happens far more than anyone is aware.'

Two Sisters

Deena Beverley

Some messages are meant to be read openly: updates on train delays, blinking dispiritingly on station information boards; newspaper headlines; electronic advertising billboards urging us to buy this, try that. Others are delicious shared semi-secrets: notes covertly passed under the desk between schoolfriends; Valentine's cards from mystery admirers.

Some messaging is meant to be heard, but isn't listened to or acknowledged. This piece, one of a pair, speaks, or perhaps more accurately, whispers, of events from my childhood that were not spoken about for many years, by me or anyone else, not even to my sister. The companion piece to this work, dedicated to my sister, is currently in process.

Tucked into the folds of the back of the skirt of one dress, removed and added to the front, are symbolically red thread hand-darning stitches, concealing a stain which has not been removed, even with repeated laundering through the years. The darning stitches speak of mending that can heal and conceal, but never erase, the marks of the past. Just above the darning stitches are French knots, forming stitched Braille letters, spelling out the word 'NO'.

Below: *'Two Sisters' (Deena Beverley). Vintage seersucker dress with hand drawn and embroidered additions, dislocations and relocations.*

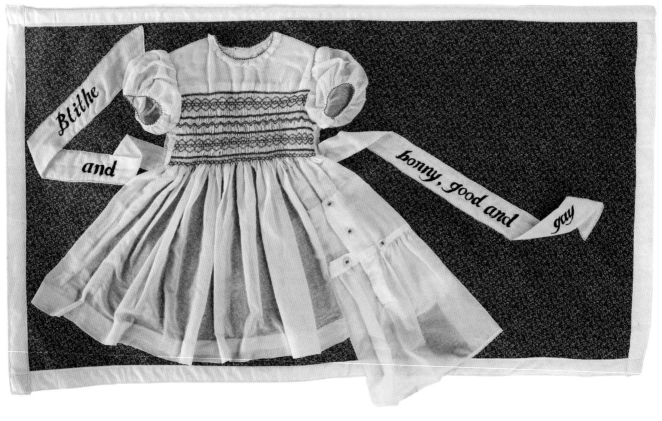

Above: Details of 'Two Sisters' (Deena Beverley). My grandmother was superstitious about red and white; 'blood and bandages' she'd mutter, genuinely anxious if I paired them in any visual way.

When displayed, these stitches are not visible; hidden under the added skirt, neatly buttoned away. Yet it is clear to the viewer that there is something 'not quite right' with this picture – at first glance perfect, a fresh-as-a-daisy seersucker tribute to the maker's immaculate hand smocking. Even the way the hooks and eyes are attached is a work of art; secured with miniscule buttonhole stitch to cover the majority of the metal.

The added skirt part subtly disrupts the perfect symmetry of the dress, inviting further consideration and examination. However, the stitched messages underneath the skirt are visible now only to anyone opening the skirt uninvited.

The freehand embroidered text on the undone, splayed sash speaks of the socio-cultural expectations associated with the day of my birth, to which I adhered as much as possible; so much so, that I was an obedient, sitting target for unwelcome predatory attention.

Melissa Averinos: My Brother's Jeans

Deena Beverley

Below: *Detail of 'My Brother's Jeans' (Melissa Averinos). The quilt's quiet beauty belies its origins, raw in both physicality and emotionality. Having lost her brother to suicide, Michael's jeans, rescued by Melissa, later kick-started this piece, which she started on his birthday.*

I first encountered US-based artist Melissa Averinos when I was commissioned to profile her for a magazine. Over the intervening years, and across the miles, Melissa has become a friend as well as a colleague. We connected over our shared experiences of having lost family members and friends to suicide, a subject alluded to indirectly in Melissa's award-winning quilt, 'My Brother's Jeans'. A few years after she lost her brother Michael to suicide, she began harvesting fabric from his jeans, which she'd 'rescued from a dumpster', for inclusion in a quilt, selecting, she explains, 'the worn and ruined parts...that were most interesting to me'.

Playing with the pieces on her design wall, a cross-shaped motif quickly evolved, chosen for its visual impact rather than for any other significance, although Michael's profession as a tile installer is reflected in Melissa's choice of a grid pattern for the quilting stitch, and possibly is unconsciously behind the choice of a strong cross pattern for the motifs; striking against the low-volume background of pale scraps, including novelty cat prints. Humour runs throughout all Melissa's work, writ as clearly as her messaging of serious subjects. Melissa tucked pieces of gold ribbon behind ripped denim patches, feeling that 'it just needed some gold'. The quilt 'just made itself' she says, adding: 'I did it all day for a few days. That's the joy of imperfection. The design happened naturally.'

When 'My Brother's Jeans' won Best in Show at Quilt Con, there was some public

pushback for the choice because of its lack of technical perfection, although Melissa was meticulous in her binding of the quilt, considering the finished quilt 'a technical progression' from her usual raw-edged work. Considerably more people, she says, 'told me how much they love it for that reason, that it doesn't have to be perfect to be beautiful. Sometimes the emotion of something is more important than the perfection.'

When people became aware of the story behind the fabric used in the quilt, a second dialogue began about its place as an iconic piece of subtle yet powerful textile messaging about mental health issues. It whispers, rather than shouts, about subjects that, although sadly all too prevalent, are still so often not in the forefront of daily dialogue.

'It's a conversation-starter when people find out about my brother,' says Melissa. Open about her own battles with depression, she adds that 'people come out of the woodwork' to talk about suicide or depression in their families: 'I love that it invites people to talk about things that they normally wouldn't bring up. I think people are hungry to be authentic and connect.'

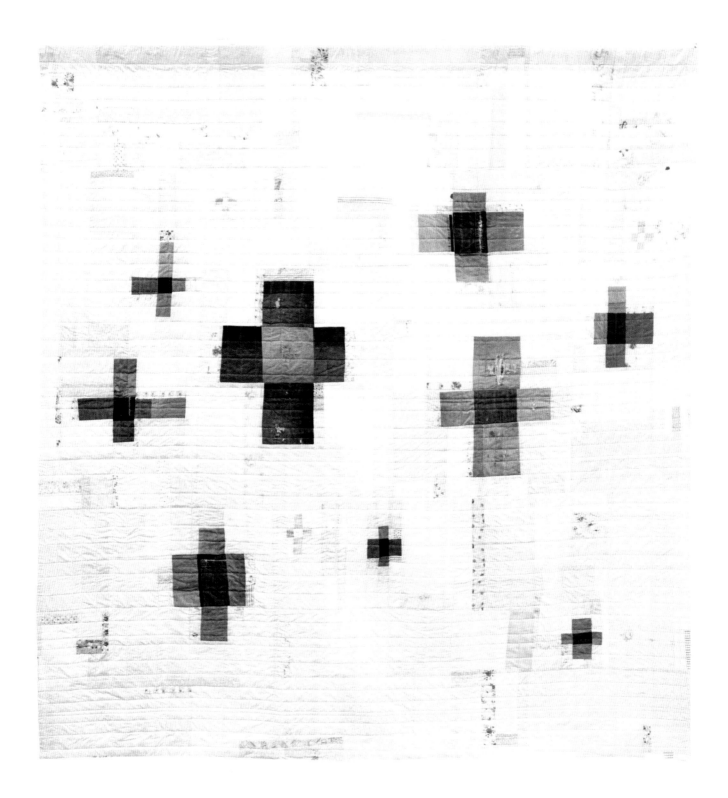

Above: *'My Brother's Jeans' (Melissa Averinos). Intuitive quilting including found, personally significant, materials.*

Memory

Cas Holmes

The glimpse of an old cotton party dress hanging in the back of my mother's wardrobe evokes memories of simpler days, and of the games I played when my worries were those of a child. In 'Memory', the shape of a child's dress is cut out of a small vintage tablecloth stained with ink and plant dyes. Cut-out holes are created in the cloth, traced from patterns found in some fine lace too precious to be cut or painted. These patterns echo the cellular structures of the human brain seen under the microscope, and those found in plants and leaves as they decay. Working from both sides, the 'unseen' side informs the face of the piece. I enjoy the unpredictable nature of the stitch 'patterns' that evolve from looking at the reverse of a piece of cloth, and the alchemy it goes through with handling. In the mending of this degraded, worn cloth, I am embracing the imperfect reality of a mended life.

Above: *Detail of 'Memory' (Cas Holmes) showing a rubbing made of vintage lace on the cloth surface. The pattern carries the 'memory' of the original lace.*

Investigating Precious Cloth

In the creation of the tablecloth series, I explored 'non-invasive' methods of using some of the more precious vintage cloth, by tracing the patterns so I did not damage them. You could try some of these methods in your own work:

- Photograph the textile or take a scan. This resulting image can be printed onto another cloth using commercial iron-on textile transfer paper, or by using the image-transfer method described on page 25.
- Trace the patterns you see in the cloth, or create simple drawings of the stitch, frayed edges, seams, or other elements in the textiles that interest you. Develop your own hand or machine stitch samples from these studies.
- Create a rubbing on cloth or paper from textured embroidery, lace or weave, using a soft wax crayon or graphite stick. In 'Memory', the pattern was directly transferred onto the dyed cloth and then machine stitched; sections of the pattern were carefully cut out with a scalpel and fine scissors.
- Make stencils for dye or paint techniques from your drawings. Some of the overlay lace patterns in 'Absence' (see pages 98–99) were made with stencils.

Below: 'Memory' (Cas Holmes). Exhibited in 'Storytellers' at the Beaney House of Art and Knowledge, curated by Natalie Banaigs, 2023–4. 120 x 120cm (47 x 47in).

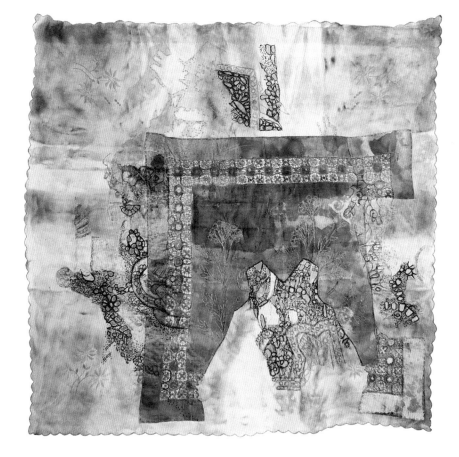

Opposite: Sketchbook and machine-stitched samples exploring non-invasive methods of using lace and fragile cloth. Studies are from photographs of poplar tree branches of brain scans onto which I have layered papers, drawing and stitch.

Anastasiia Podervianska: Cultural Resistance

Cas Holmes

The multi-layered stitched collages of Ukrainian artist Anastasiia Podervianska combine Ukrainian decorative and ethno-romantic traditions with strong graphic motifs that give her works a cross-cultural resonance that challenges the stereotype of textiles as a decorative and applied medium for women's handiwork. Using symbols and signs, Anastasiia visually reimagines traditional iconographic motifs, transforming them emotionally and lending them new meaning. This is evidenced in a powerful body of work about the war in Ukraine, which shows apartment blocks and schools being destroyed by Russian air strikes, and about which she writes:

> 'Everyone who stayed here is trying to live as usual. But this is often very hard. We live in a world where air alarm sounds and rockets attack the city of Kyiv, and daily news brings the information of more shelling and loss of life across the country. Now our whole country is working to defeat the enemy. Ukrainian artists try to voice their

Opposite: *'Air Raid Alert Map of Ukraine'. Hand-tufted red threads. 150 x 120cm (59 x 47in).*

Below: *'Borodyanka and Mariupol', 2022, textile, hand embroidery. Missiles landing onto buildings are appliquéd onto beautiful panels of traditional floral embroidery. 75 x 230cm (30 x 90in).*

opinion about this war to the people. They organize
exhibitions and auctions in support of our army.

'"Air Raid Alert Map" is the "bloody" map of Ukraine.
We see this map in the Messenger App when the air alarm
sounds. The map shows where there is a great threat to
life and where active hostilities are taking place. Often,
the whole map is red; only the still-occupied Crimea
remains white. Everything inside me freezes and stops for a
moment when I hear the sound of a siren.'

With a complex history of war, colonialism and political
upheaval, Anastasiia's use of these traditional textiles is
a reminder of Ukraine's rich cultural heritage and deep
artistic traditions; and that in her eyes, Russian aggression
is not limited to military action alone, as it seeks to
undermine the national identity and democratic rights of
the Ukrainian people.

Lorina Bulwer: Speaking Her Truth

Deena Beverley

A long, diverse canon of embroidered and appliquéd works exists, stitched to communicate text meaningful to the artists. Banners and badges naturally fall into this category, created to convey messages to the wider world, while others are intensely personal. It isn't always clear whether the intention of these pieces, often worked in extremis, were made in hopes that they'd be read, or whether their primary function was simply to get the words out of the stitchers' heads while providing occupation and distraction for troubled souls. Certainly, the latter has been the case for me throughout my life, in words written or stitched, especially when I've felt constrained.

My own experiences make me realize there can be no accurate way of ascertaining what Lorina Bulwer, born in 1838, was hoping to achieve when she stitched her monumental embroidered invectives while in the Great Yarmouth workhouse, where she was classified as 'lunatic', and where she died in 1912. Lorina's embroidery is work I hold close to my heart and head for its untrammelled expressionist quality, and it has an extra, personal, level of relatability. My great-grandmother had lived experience of a Norfolk workhouse but was reluctant to recollect it, as it had been deeply traumatic. Decades later, I had similarly harrowing experiences of the Great Yarmouth asylum, anything but a 'safe harbour', and eventually closed down. Had I been incarcerated for as long as Lorina, I'm sure I'd have produced similarly vocal work.

In any of my various hospitalizations, words have been my outlet. Under extreme duress I become what I've only recently discovered is termed 'hyperlexic', something certainly shared with Lorina. In times when I feel no other locus of control beyond expressing myself in words, whether spoken, written, screamed or stitched, it helps.

Lorina Bulwer and many other artists with no outlet beyond stitch or paint to convey their truth, are not spectral figures from the past; they're the forebears of anyone with untold stories to tell. If we don't share our own painful stories, how will others suffering similar difficulties know they're not alone? Stitch is a gentle, calming way to begin to reveal that which you might not otherwise feel able to vocalize, even if only and most crucially to yourself. Start small. One word, hand embroidered on a small piece of found cloth, might be all you need to experience the kind of release you couldn't previously have imagined. You need show no one else. Float it away, bury it, or burn it and cast the ashes of your work, and your pain, to the winds.

Opposite, above and right: *Lorina Bulwer's epic stitched epistles speak for her down the ages. Wool on cotton. Courtesy of the Norfolk Museums Service.*

Dreaming in Three Dimensions

Deena Beverley

Embroidery doesn't have to be flat, framed, or have its structure defined in any way. There really is life beyond the hoop. Three-dimensional textile work has long been a part of my life; in my career in costume design for TV and film, work in the theatre and in art direction, set styling, design and prop realization, as well as in my own vocational work. Early experiments with soft sculpture were great fun, making a huge fabric mushroom with help from my mum who, having a part-time job picking mushrooms in the dark in Nissen huts, had first-hand experience of every structural detail. I can still recall the exact fabrics from which it was made: a cotton needlecord stem; reversed satin (matt) pleated gills; and a hand-painted cotton-velvet cap; the whole enhanced with hand-stitched details and manipulated fabric additions to make it 'perfectly imperfect'. An enormously pleasing piece to handle, its tactile appeal stayed with me, and I've made dimensional textile pieces ever since.

I like to make richly embellished, removable covers for books, such as the kantha cover worked in silk rags patched together shown here, with a pocket for notes, made from a scrap of deliciously thin calico tote bag (which I also used for the face of the figure in 'Kiss, Clasp, Crown' on page 75, and shown below). The book is a perennial pocket 'year' book of daily meditations full of insightful inspiration that I value and dip into regularly, so I wanted to accord it an elevated status by making this textile wrapping, which also protects it.

Above: *Kantha book cover by Deena Beverley for the book 'Opening Doors Within' (removable, with integral pocket).*

Below: *Detail of 'Kiss, Clasp, Crown' (Deena Beverley).*

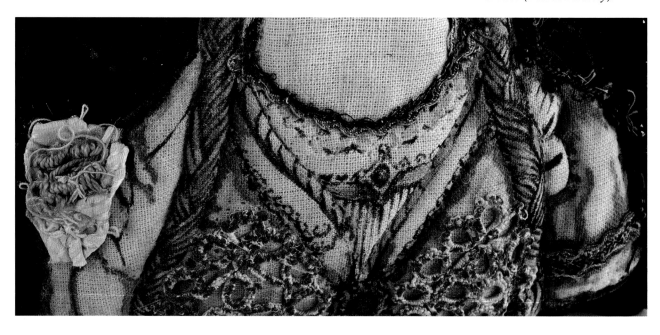

Japanese Inspirations

Cas Holmes

Early studies in Japan with the Churchill Fellowship and later with the Japan Foundation gave me an insight into the flexibility of paper, and its usage and integration with cloth. Oriental and conservation papers have longer fibres and a softer, more cloth-like feel than many Western papers. Indeed, in Japan, *kamiko* (paper clothing) is created out of kneaded, hand-made paper called *momigami*. I have since remained fascinated by paper's potential to be rolled, folded and shaped, to take up dimensional form from an otherwise 'flat' plane.

Emakimono, the traditional Japanese scroll construction, provided the perfect framework for telling the story of my daily walks around a Japanese garden in Tokyo. The individual scroll lengths are printed with images of items seen or collected on the garden paths, and are combined with fragments of a vintage kimono and indigo-dyed *boro* cloth. Each scroll fits into its own box, covered in washi (hand-made Japanese paper) salvaged from an old book. The piece celebrates the significance of those collections for my continued learning and love of Japanese culture today.

Above: *'Emakimono'.*
Eight pieces, each contained in a box 16 x 6 x 6cm (6 x 2½ x 2½in). Vintage washi paper and kimono fragments, photo transfer, printing, machine and hand stitch. Exhibited with the Embroiderers' Guild 2022 at the Knitting and Stitching Show.

Clarissa Callesen:
Joyful Busara

Cas Holmes

American artist Clarissa Callesen creates sculptural forms with post-consumer-found materials and by-products of industrial production. Inspired by the colours, texture and shapes of these objects, her interest lies in our interconnection with this commonplace matter and the sculptural possibilities it presents.

'Joyful Busara' explores the things we are often reluctant to talk about in Western culture: death and mental health. Clarissa describes a visit to a Mexican graveyard in a small town called Chapala:

> '"Joyful Busara" is a work that came out of my love and adoration of a different culture's relationship to death. Every day, no matter the time of year, a Mexican graveyard looks like the day after a raucous party. The pathways and fences are littered with colourful trash and evidence of human joy.'

Clarissa respectfully collected pieces of brightly coloured graveyard trash and took the treasured garbage home to her studio in the USA. In the time of COVID, discarded disposable face masks joined torn silk flowers. As Clarissa was working, her eyes were drawn to a large box of brightly coloured medical waste that she had collected for years. Clarissa adds:

> 'Depression has been a part of my life for the last 30 years, and with that comes hundreds of bright orange pill bottles. Those pills allow me to live, to make art, and to find joy in this beautiful, complicated world. Remnants of those bottles became a finishing touch for "Joyful Busara". Those bright orange bottles are a part of my colourful life. They are with me every day, whether I am in my cold northern studio or in a sunny Mexican graveyard.'

Western culture has a mostly stoic relationship with illness, death and graveyards. In 'Joyful Busara', Clarissa turns this fragile relationship with the materials and with life into something worth celebrating.

Right and below:
'Joyful Busara', 16 x 43 x 20cm (6¼ x 17 x 8in). The brighter celebratory colours of the mostly plastic garbage used in 'Joyful Busara' were a departure from Clarissa's normal earthier tones. Fragile from being in the hot sun, each piece had to be stabilized, and the flowers reinforced and mended before being added to the sculptural form with stitching.

Kiss, Clasp, Crown

Deena Beverley

Above and below: 'Kiss, Clasp, Crown' (Deena Beverley). Ink and found fabrics attached to found vintage early celluloid frame with integral chain.

The 2021 Embroiderers' Guild competition brief 'Exquisite Containers', combined with life still being very much in 'on/off' pandemic lockdown, provided me with the perfect opportunity to develop this richly detailed, complex three-dimensional piece, which won an Embroiderers' Guild Artistic Director's award for Creativity and Innovation.

I was born a stone's throw from Norwich Cathedral, in the heart of the medieval city, where ancient religious imagery was on every corner. Reliquaries (receptacles for the relics of saints) have long been an obsession of mine, and I based this piece on one that depicts one of the companions of Saint Ursula, who were martyred en masse during a pilgrimage to Rome. Often gold edifices, sparkling with jewels, this one captured me with its quieter rendition of Saint Ursula's companion as an actual person rather than as a gilded saint. I am always more interested in the lives of ordinary people than those elevated in society by money and stature. Palatial stately homes hold little appeal for me; they are so much less relatable than more diminutively scaled domestic dwellings.

Born at the other end of a street leading to the cathedral, home was a mid-century council flat off Magdalen Street. I referenced both my humble origins and the restrained intimacy of the subtle reliquary by drawing the image in sepia ink onto the reverse of an old calico tote bag. Pleasingly thin and cheaply made, it had just the kind of fragility that I wanted to represent a real person, not an immortal, elevated being. Feeling increasingly connected to the figure as I worked, I added cherished fragments of a Victorian mourning dress and black jet mourning beads to honour the savagery of her passing. I sealed the piece shut, having stuffed it with salvaged padding incorporating a secret message. It felt as if the figure began to smile back at me, a curious thing that often happens as I create these faces. Her secret is safe with me.

I had intended this piece to represent the approachable human face of a reliquary figure quite unlike her grander counterparts, but, ironically, I will likely have to display her beneath a glass dome when next exhibited, as visitors so often try to see what secrets she holds. Quite unintentionally, she has acquired something of the presence of those gilded saints, who invite reverent touching by pilgrims' hands. Though I'm under no illusion as to why people are so keen to investigate her contents; for most people, she is more handbag than saint.

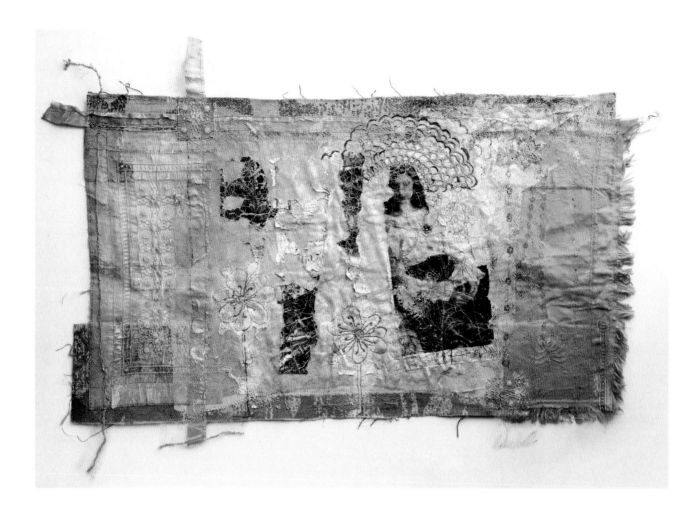

Sight Unseen

Deena Beverley

The working title of this piece was 'Brocadey (sic) Lady'. I often give silly, singsong names to work-in-progress pieces whose meanings are anything but frivolous and light-hearted. It was constructed on a background made of a shattered vintage brocade wedding dress, bought in the early days of my relationship with my now husband, when living in London.

 This work, like many of my pieces, was created over decades, with long tracts of inactivity between each session, not because of creative block, but because the rest of life got in the way. Each time I reconnected with the piece, something had shifted in my life, which adjusted the intentionality of the work. I started it over 30 years ago: an optimistic, gently sparkling, layered brocade and antique lace background, awaiting some kind of similarly crystalline-clad maiden archetype in harmony with the youthful version of myself, who'd bought the wedding dress in a whirl of enthusiasm for life,

'Vision is the art of seeing what is invisible to others.'

Jonathan Swift

Opposite: *'Sight Unseen'*
(Deena Beverley). Paper
and stitch on vintage
damask with found
fabrics.

Below: *A large part of the*
face is missing here, eroded
by invisible forces. Only
now do I notice that the
negative space resembles a
wolf closing in on its prey.

love and all things vintage. Then, along the way, life happened, and with it, a slow erosion of the maiden archetype I'd thought I would make. This wasn't so much in the way I viewed myself, but in the way I experienced it, particularly in my years of working in casting and styling models for photography, film commercials and print ads. The treatment of women in that industry, as if Madonna or whore, often both simultaneously, irrespective of the way they presented themselves, and the subsequent serious abuse was legion; it is only now being exposed through the courageous women who've come forward to share their stories.

I'm still not brave enough to fully relate my own experiences publicly, especially when some of the people involved are high profile and still alive. I'm not proud of my reticence, priding myself as I do on 'never knowingly being lost for words', as my husband puts it.

For now though, this work will have to speak for me. Mostly made of stitched found paper, chosen for its fragility and deceptive strength, the image will continue to degrade faster than if made with more robust materials; a deliberate choice, reflecting my own, unexpected fragility despite appearing strong.

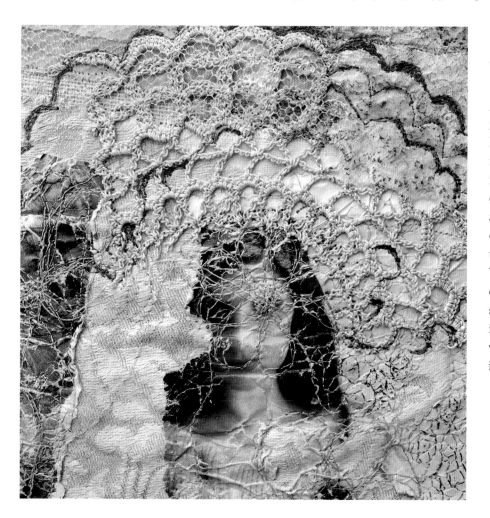

The female figure sits mute, surmounted by a halo, festooned in flowers, bedecked in blooms on all sides. Superficially, life is good. She is at the top of her game, adored and adorable, highly paid, elegantly dressed in beautiful clothes, living in one of the world's most exciting cities, the world at her feet. And yet... look closely at her face, which tells a very different story. Yes, of course she's me. She's every woman who recognizes some aspect of herself in this image and these words. She's veiled, but softly, slowly, she is learning to speak out.

Working with Paper: Preferences and Practicalities

Deena Beverley

Below: *'Petal Dust'* *(Deena Beverley). My paper additions are never a token addition to textile pieces. Chosen for layers of meaning as well as their haptic appeal, I integrate them carefully into their backgrounds with added, often shrouded, significance.*

The 'handle' of the materials I work with is hugely important to me, and I have recently discovered that being exceptionally sensitive in a tactile sense is all part of the picture of neurodivergency. Some materials I find almost physically intolerable to touch, notably microfibre and synthetic fleece, but those I do enjoy handling bring me inordinate pleasure. I am genuinely excited by the way that paper feels, for example. Used, once-stiff paper, in particular, often has a kind of hard/soft, crisp yet yielding deliciousness that half bends, half cracks when you fold it. As a bonus, crisper materials can be embroidered without being hoop mounted (I hate working within the constraints of a hoop, although I acknowledge their usefulness in some kinds of embroidery).

Paper, just like fabric, is a material. Since some paper is made from rags, and some fabric is made from wood (viscose), it makes sense to regard fabric and paper as materials in equally valid ways when creating textile art. However, there are some notable differences worth considering.

Durability and Dialogue

Will your work be handled regularly, or is it primarily for display? How important is the meaning in material choice to you in creating your work? Some of my pieces are created with papers already on the point of disintegration, chosen because I'm drawn to their fragility in every sense. Their being at the point of collapse, yet still extant, has a clear symmetry with my own experiences and of the essence of the human condition, and this kind of relational depth to material choices is an important aspect of my work. It might not be to you, and that's equally valid. If you prefer to use a particular paper just because it's pretty, then that's an important choice on a different level. Just enjoy 'the choosing decision'; it's a key part of everything you'll ever make.

Considerations Practical and Poetic

Sometimes I like to use papers that are really fine and floppy, which feel so gentle to work with; tissue paper that's been reused so much it feels like an old silk handkerchief. Sometimes I strengthen them by heavily pasting them, supporting them on other substrates, or part shielding them with tulle. Other times, I'll use them exactly as they are, allowing them to continue their disintegration uninterrupted as part of the meaning in the piece.

Stitching into paper and card that are crisper and firmer than my softer choices, I find the feeling of piercing paper and card with a needle is so visceral, so sharp, that it brings strong images to mind, such as the beautiful sight and sound of a swan determinedly breaking a path through the ice for her cygnets. Once you've pierced the card or paper with your needle, that hole is there forever. So pierce with the awareness that your mark is permanent. This enforced mindfulness is a significant part of what makes stitching with paper and card, in my experience, so therapeutic. Entering a 'flow state' comes with this territory.

Paper and card are, of course, the sworn enemies of sharp scissors and needles. Keep needles and scissors used for paper and card in one place, clearly labelled. If stitching with paper on the sewing machine, change your needle even more regularly than usual and thoroughly clear out the bobbin race equally often.

Petal Dust

This piece incorporates a cherished piece of age-softened Edwardian ephemera – an old paper sachet, which once contained dried flowers purported to deter moths – with scraps of found fabrics. Worked almost entirely in intuitive free-motion embroidery, with highlights of hand embroidery, the stitchery continues in the free-motion embroidered foliate lace that I made to take the work beyond the edge. Flowers are the dominant imagery used, honouring the sachet's original contents.

Petal Postcard

I have an extensive collection of vintage postcards; some embroidered, some plain. I display them in our kitchen in the plastic wallets in which they're usually sold, temporarily attached to the wall using Blu Tack so I can rearrange at will. The plastic wallets protect the cards amazingly well from the grease and grime of life in a tiny cottage kitchen. This card I hand embroidered with found vintage thread to demonstrate just how beautifully impactful even a few hand stitches can be.

Above: *'Paper Roses'*
(Deena Beverley). Antique
postcard with stitch in
found thread.

Glimmer

Cas Holmes

Edging the space between our garden and Mote Park in Maidstone, Kent, stands a row of tall poplar trees. Their familiarity is comforting and we enjoy seeing the changes through the seasons, and at different times of the day, as the light hits the trees and chases glimmering shapes through our windows. The shadowy patterns cast by the branches' foliage and those seen in scans of the brain's neural pathways resonate.

Trace particles of gold in the human body play an integral role in the transmission of electrical signals. The glimmers of the synaptic connections being made and of the light coming through the trees are hinted at in the patterns and glimmers of gold in these works. The making process, each stitch and mark, mirrors the regeneration found in nature and damaged neural pathways.

'Glimmer' is an exploration of interconnections. Both the tree and brain when damaged are capable of growth, healing and repair.

'Ring the bells that still can ring
Forget your perfect offering
There is a crack, a crack in everything
That's how the light gets in.'

FROM 'ANTHEM' BY LEONARD COHEN

Opposite: 'Glimmer 3' (Cas Holmes). Medical wrappers and text trapped within the layers of dyed and stitched cloth.

Below: 'Glimmer 1–3' uses older works and 'discarded samples' as a base, which are overlaid with finer heat-transfer dyed cloth. As the work evolved, reusing these 'forgotten' and 'rejected' cloths also became symbolic of the process of repair. Overall size of installation 350 x 70cm (138 x 28in).

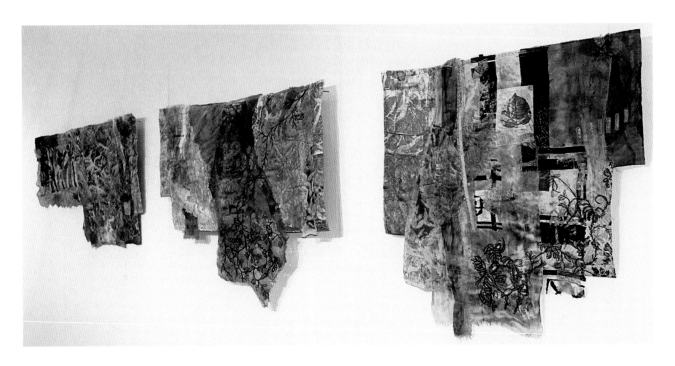

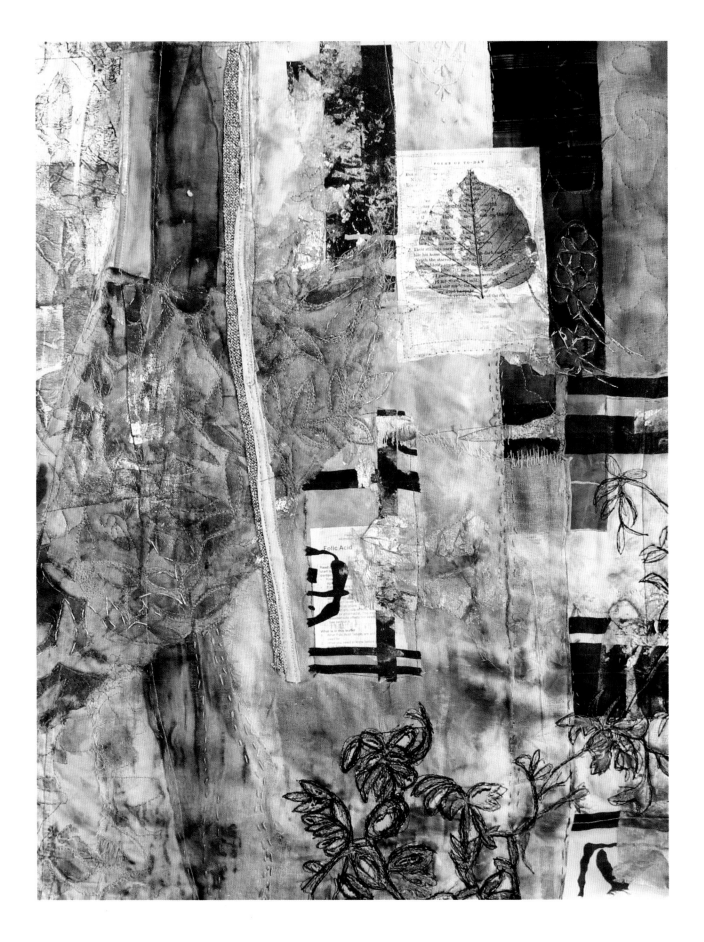

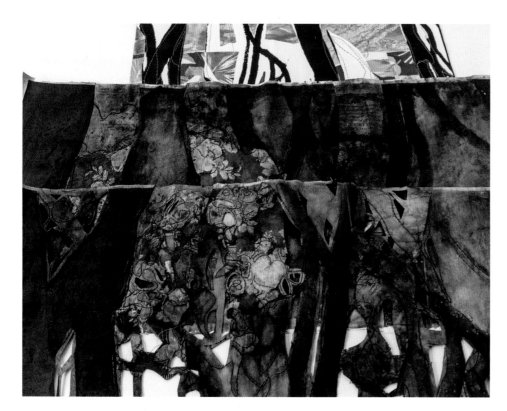

Left: *Paper bags and photocopies of trees stitched together. Dyed and stitched paper. Dyed papers with sections cut out ready for transfer.*

Above: *A range of transferred images using the dyed cut paper shown in the top image on different weights of synthetic cloth including a polyester shirt. This demonstrates how dye colour can shift in the process of transfer.*

Glimmer Process

The fine overlays in the 'Glimmer' series are achieved by using dyes applied to window sheers using disperse (heat-transfer dye) treated papers. The dyes come in powder or liquid form and are intended for use on synthetic fabrics, such as polyester, nylon and poly-cotton blends that have a synthetic fibre content of more than 60 per cent. Quantities for usage will vary from manufacturer to manufacturer, depending on the type of cloth used.

Preparing the Paper

1 Collect a range of different types of papers. I generally find smoother, less absorbent paper surfaces work better. For 'Glimmer', I used some photocopies of the poplar trees (the dye resists the black toner areas of the photocopy), and a range of printed papers as well as medical wrappers.
2 Loosely tear and cut shapes out of the paper, and machine-stitch the pieces of paper together. The machine-stitched areas will add a layer of textured detail.
3 Cut shapes out of the layered papers to leave negative spaces or 'holes'.

Applying the Dye

1 Brush the dye onto your stitched paper and allow it to dry. I usually lay another sheet of paper underneath to pick up the excess dye.

2 Cover your ironing surface with an old cloth and greaseproof paper to protect it. Set the iron or heat-press temperature somewhere between the wool and cotton settings.

3 Lay your fabric on top of the ironing surface. Place the painted paper design on top of the fabric, paint-side down. Place a piece of greaseproof paper between the iron and the back of the design to protect the iron.

4 To transfer, apply firm pressure with the iron while slowly moving it over the paper for one to two minutes. Remove the iron briefly and carefully take a peek by lifting the edge of the paper to see if the image has transferred.

The dyed papers can be used more than once to make multiple prints. Each subsequent application will give a duller image.

Below: *Detail of 'Glimmer' (Cas Holmes). Heat-transferred shears are combined with paint and gold foil stencilled patterns to suggest layers of movement in the trees.*

'If you put frightening things into a picture, then they can't harm you. In fact, you end up becoming quite fond of them.'

PAULA REGO

Stricken

Deena Beverley

Opposite: *Detail of 'Stricken' (Deena Beverley).*

Below: *'Stricken' (Deena Beverley). Hand drawn and painted large-scale raised embroidery, appliqué and quilting using found antique fabrics, paper and thread.*

My 'elegantly wasted' 1920s boudoir doll's shredded dress and tangled hair added to her age-softened appeal. However, some imperfections appealed less. A delivery disaster detached one foot, smashed one hand, and damaged the other. My (failed) insurance claim photograph had a forensic outline 'crime scene' quality.

Her changed condition and stricken pose made me consider 'damage'. Bought after a prolonged hospital stay with the issue she had: an ankle only securable by artificial means, my operation cheerlessly dubbed 'salvage', the only alternative to remove my foot, like hers – she'd become my avatar. Synchronously, I'd also developed issues with my hands.

The piece; more emotive than envisaged, conflicted me about how much to reveal. Her detached foot still perfect in its gilded shoe, was separated from her leg, her jagged hands were horror-movie worthy. Could I bear to evoke this damage on my piece? I drew and embroidered her pierrette cuffs, leaving her hands temporarily unresolved.

Gently she rose like a phantasmagorical being from precious antique fabrics. Recreating her, in calming cloth, I had a growing sense of healing us both. She came to resemble a pale effigy; Eleanor of Aquitaine in calm repose, a victim no more.

As I have said before, I love reliquaries. Compromised by age's rigours, missing toes, feet and hands; despite their imperfections, I adore them. Food for thought.

Feeling low after my 'salvage' op, unable to focus on reading, writing, drawing or stitch, I felt I'd lost much of my identity.

An occupational therapist told me that although I felt broken and useless, I retained value. I decided to depict the doll's changed physicality; abbreviated, damaged limbs and all. It felt important to let her speak my truth as well as her own.

This piece also pays homage to Paula Rego and her work's unflinching honesty, which encouraged my hesitant moves towards revealing more of myself in my work, even when, maybe especially when, it scares me. Try it. It's powerful stuff.

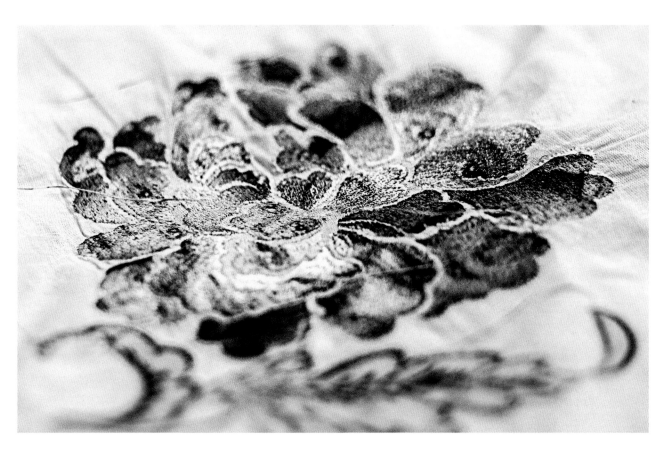

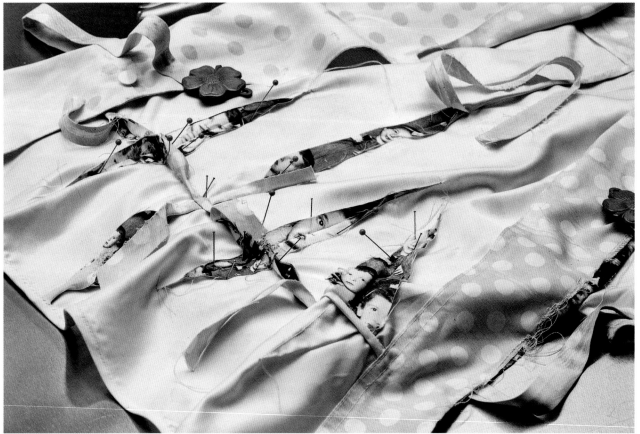

Shelly Goldsmith: Łódź Blouse Trilogy

Cas Holmes

Opposite above: *In 'Concealed', the texture of the digitally embroidered flower on the blouse obscures our ability to read the image. Only from one viewpoint, when the directional plane of threads and images align, are the girls' faces legible. Magnifying glasses are placed with the blouse to offer a visual clue to the hidden nature of the image, and the need to look closer.*

Artist Shelly Goldsmith's narrative work speaks about ideas of identity, fragility and memory imbued in the clothes we wear. In 1998, Shelly visited Łódź in central Poland, later discovering the emotionally charged documentary photographs of Jewish Polish photographer Henryk Ross (1910–1991). Ross illicitly photographed the daily events in the Łódź ghetto while taking identification card photos for his job. In 'Łódź Blouse Trilogy', Shelly pays homage to the image 'Children and parents gathered around the table at a children's party, 1942–1944'. She writes:

'One photograph in particular haunted me for many years. I taped it to my studio wall, getting to know the faces that peered out of the scene, especially those of the children. In 1944, Ross buried his photographs and negatives to protect them, returning when safe to unearth them after the Red Army's Liberation of Łódź. As a direct response to Ross's actions, I set about to embed, hide, bury, and then reveal aspects of the photograph hidden within the three blouses. I imagined how a blouse could be worn without disclosing its latent contents.

'Only through close inspection, unpicking and acts to de-construct the blouse, are the faces of the children revealed in the artwork. The blouses are presented in display cases, accompanied by related objects to aid in the reading of the concept behind the work.'

Opposite below: *In 'Unpicked', the seams and darts of the blouse have been opened up to reveal the faces of Ross's photograph looking out at you. Accompanying cutting and unpicking tools suggest the careful unlocking of the latent matter.*

Right: *Lace veils the photographic image in 'Inherited'. Shelly has used dye sublimation technology (heat-transfer dyes) to transfer the photographic images onto the blouses.*

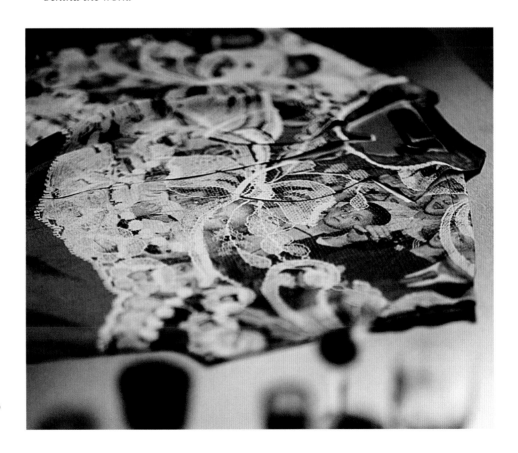

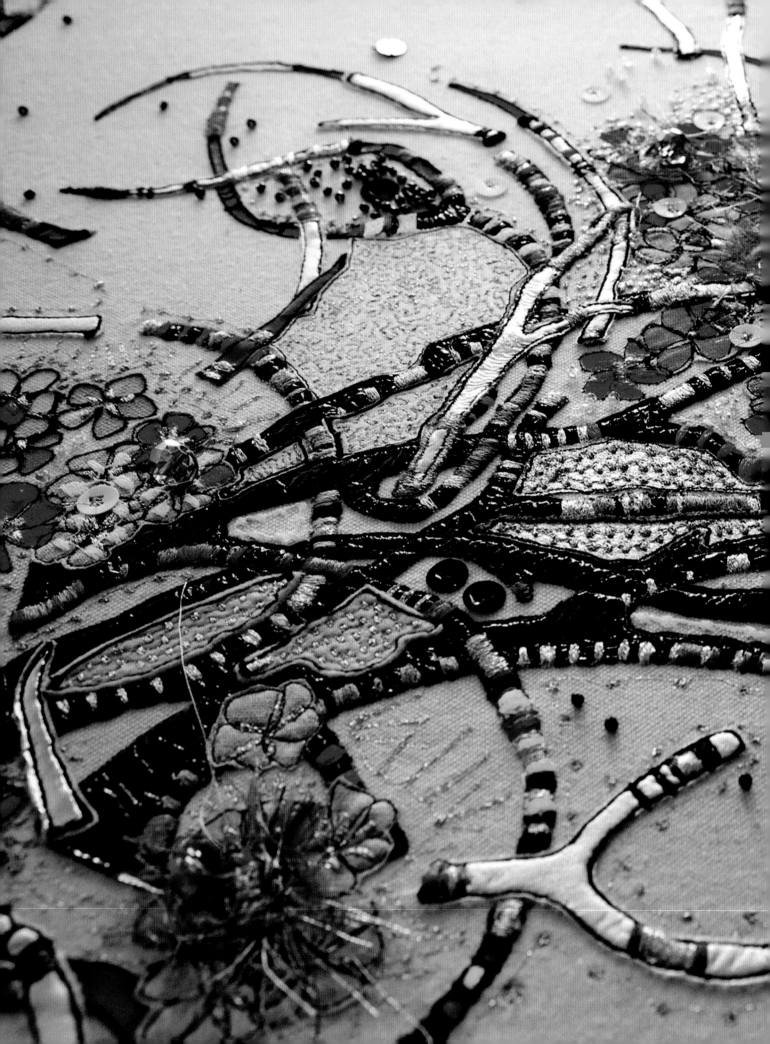

CHAPTER 4

Connections

Left: *Detail of 'Tumbleweed' series (Louise Gardiner), for 'Collect' at The Saatchi Gallery 2012.*

Connections

Stitch has a potent ability to connect people and, in so doing, to deeply enrich the human experience on multiple levels. Where once we connected through stitch primarily in person, life's challenges including the pandemic, financial, health and geographical issues have forged new ways of connecting. Here, we share how we and other artists have embraced imaginative new ways of connecting through stitch, despite multiple difficulties in so doing.

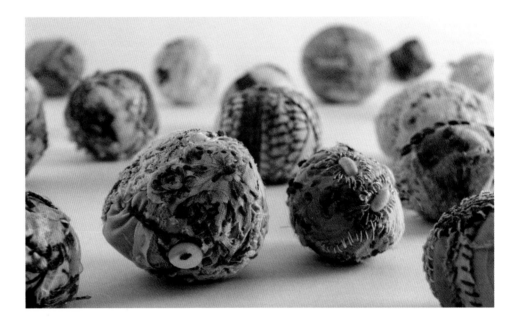

UMO: Unidentified Meaningful Object

UMO (Unidentified Meaningful Object). *Pebble-sized wrapped, layered and stitched cloth spheres and bundles. Created by members of 'What We Value, What We Miss'.*

We often have secrets or things precious to us that we may not want to share or discuss. In UMO, a collaboration with artist Liesbeth Werts, members of the group 'What We Value, What We Miss', who meet up online, were invited to find an object that had personal significance to them and to write their thoughts about that object down on a piece of paper. The paper was wrapped around the object before being bound with red thread. The contents inside are hidden in the process of adding further layers of soft cloth, held together with embroidery stitch. The object and the writing may be lost in memory, even to the maker.

One of the group members spoke of her experience wrapping the object: 'The act of wrapping in cloth softened the object; the process became more addictive with each stitch. I lost myself in the process and gave myself time out of the pressing demands of the day.' Each UMO reflects the individual's hand and is as unique as the multitude of pebbles to be found on a beach.

Louise Gardiner's Cape of Creative Courage and The Flying Acorn Army

Deena Beverley

A luminary of contemporary embroidery, Louise Gardiner was a passionate and courageous ambassador of stitch. Renowned not only for producing vividly energetic and complex designs for clients including Liberty, The RHS at The Chelsea Flower Show and Collect at The Saatchi Gallery, but for her infectiously enthusiastic approach to sharing her skills and her passion for the positive power of communication through stitch, she leaves a legacy as richly coloured and inspirational as her personality.

Right up until her death, Lou was working on a major commission for the third in her 'Capes of Empowerment' series, embroidered capes that were designed 'to wrap [people] up, celebrate them, protect, nurture and surround them in love', in effect turning the wearer into a 'superhero, part of the artwork'. Despite being seriously ill, her vivacious personality continued to shine in interviews and social media content, just as it had always done, infusing others with her irrepressible and irreplaceable spirit. As an ambassador of connectivity through stitch, she is a true icon.

It is said that when we pass, we die only when we are no longer talked about. Lou Gardiner's legacy, like that of the equally memorable embroidery advocate Constance Howard, will live on not only in her exquisite work itself, but in all the beautiful work that she has encouraged others to make and share, believing passionately that, 'My experience as an artist, designer and maker has shown me embroidery's power to inspire sharing, energy and creativity. I aim to create new opportunities for positive interaction with this authentic and exciting medium.'

Speaking of the immense task of undertaking her final commission, the 'Cape of Creative Courage' for Marchmont House, pictured here, and facilitating and encouraging her 'Acorn Army' to add their stitched voice to her project (to which Cas and I have both contributed), Lou said in interview with Zak Forster, with characteristic understatement, 'It's ambitious, but I am ambitious and I love doing projects that have an infinite nature. You have to give the acorn wings, and you never know what's going to happen.' The scale of the success of her open call 'Stitch a Cloud' project 'was such a surprise' and taught her 'the energy and the love that you can ask for if you want it...you just have to ask'.

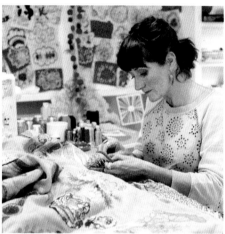

From top: *Lou in her studio working on the 'Cape of Creative Courage', supported by members of the Acorn Army; Lou working in her studio on 'Cape of Empowerment' for the Womankind Pukka project; 'The Dream Tree' (private commission).*

Vanessa Marr:
Domestic Dusters

Cas Holmes

In 2012, as part of her academic research, artist Vanessa Marr explored the original oral traditions of fairy tales often told by women as they worked at home. In response, Vanessa began embroidering a collection of seven dusters entitled 'Promises and Expectations', which challenged the notion of domestic happy-ever-afters often recounted in Grimm's retelling of the gendered relationship women have with domesticity. The research formed the roots of her long-standing 'Domestic Dusters' project, inviting women to embroider their thoughts and images connected to the domestic experience on these soft yellow cleaning cloths. Vanessa elaborates:

'The project asks how hidden and silenced female domestic experiences can be voiced through collective craft practice and explores how the duster, which signifies domesticity through our cultural knowledge of its purpose as a cleaning cloth, can act as a catalyst for change through collaborative and collective making.'

Below: *'Domestic Dusters' on display at the University of Brighton.*

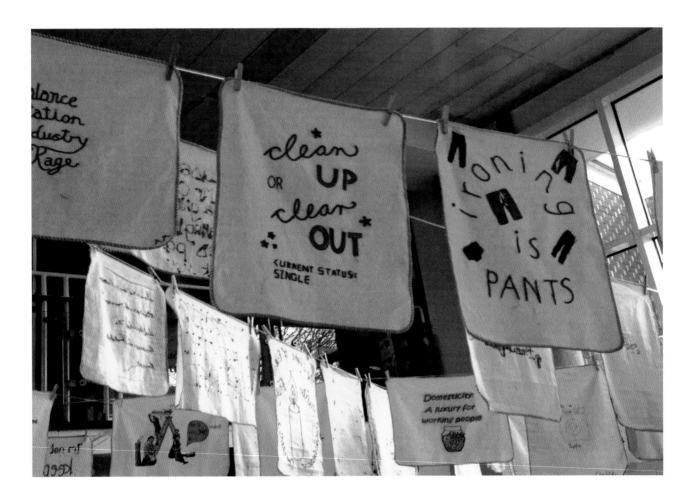

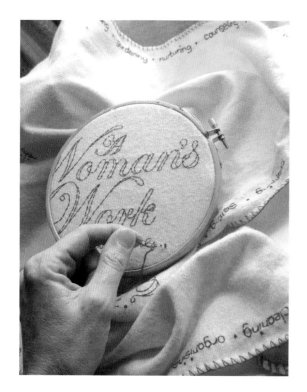

'My provocation, "women, and domesticity – what's your perspective?", is intentionally open and subject to personal interpretation. It has introduced me to countless amazing women from across the world, each exhausted by the legacy of domesticity that they struggle to shake off. While conversations often begin around cleaning, this is not the focus; rather, it is a route to discussing women's lived experiences of care, the mental load, and the sharing (or not) of housework and other domestic responsibilities. The experience of embroidering a duster for exhibition also addresses the benefits of stitching for health and wellbeing, the solidarity of group participation and common experience.

'This humble, invisible cleaning cloth holds our trials and tribulations in its weft and warp. Each stitch upon it calls for change and unites us in adversity, fighting against the tyranny of the kitchen sink through the power of storytelling, stitching and activism.'

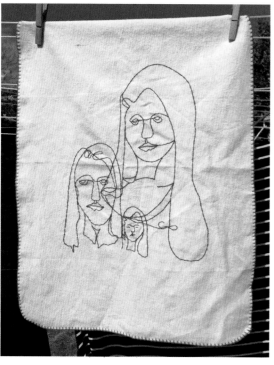

From top: (Vanessa's) hand stitching 'Women's Work'; Vanessa's 'Self Portrait' hanging from a washing line in her garden.

Stitching: A Sensory Connection to Others

Cas Holmes

Collaborating and interacting with other people through sewing gives us a sense of being valued through a collective interest in a common endeavour. As the needle passes through the cloth in our hands, the act of stitching provides a sensory connection to our memories and emotions.

For many who are more limited in their daily interactions due to illness or circumstance, working or communicating remotely from home using various online platforms is a powerful tool of connection. As a 'traveller stilled' by my caring role, I have sought a variety of means of retaining a connection with 'my tribe' of textile friends, by being involved with community-based projects whenever possible.

Yet, as we become more physically distanced from each other, the digital screen cannot recreate the connection that comes from looking someone in the eyes and responding to the overall warmth of sharing a space with another human. Sewing is a way of sharing; it sustains a sense of belonging and acts as a safeguard against isolation.

My contribution to the Domestic Dusters project can be seen on page 33.

Beltane

Deena Beverley

The lockdown of the global pandemic of 2020–2021 has cast a long shadow. Confined to our own homes, we learned to adapt and online connection became key to many aspects of a radically changed daily life. During this time, online buying and selling grew in importance as ways of accessing both materials and much-needed extra funds. During my 'Attic Treasures' workshop, delivered through the Embroiderers' Guild, one of my students brought her exquisite collection of vintage textiles gathered during her career as a costume designer. She had been mistreated by a local vintage dealer who'd trash-talked the collection in attempts to secure a lower price; given my connections within the world of costume and vintage textiles, could I help? I offered to research and sell it for her to ensure she, and her cherished collection, were treated fairly.

Along the way, I made connections with the online vintage world, and as lockdown really sank its jaws in, these online relationships became increasingly important. Relationships beyond the merely mercenary were forged and deepened, such as that with Susie, the young woman who was the muse for this piece. Not intended to be an exact likeness, it is an attempt to summarize in textile form Susie's irrepressible zest for life that uplifts and inspires, even via the sterile medium of a phone screen.

Despite suffering multiple debilitating chronic illnesses, Susie refuses to be defined by her conditions. She and her twin sister are successful vintage dealers; familiar, popular faces on the scene. They socialize with as much colour and joie de vivre as the clothes they wear and sell. 'Beltane' was inspired by a selfie Susie snapped on a typically spontaneous outing. Socializing and working are painful, challenging and fatiguing because of her health conditions, and making the effort to do either bears a legacy cost in terms of severe exhaustion, yet Susie and her sister have beamed sunshine into my life on the greyest days. I, in turn, have sent words of encouragement when the sun has gone behind a cloud of illness or other misfortune. I've yet to meet Susie in real life, but she's no less a real and valued friend to me for that.

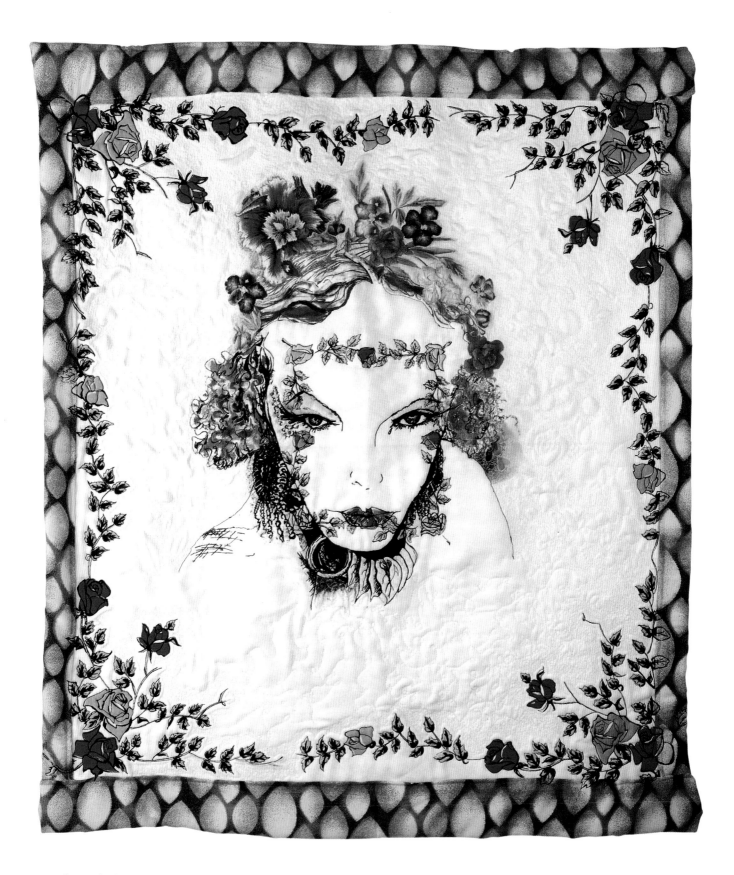

Above: 'Beltane'
(*Deena Beverley*).

Intuitive Quilting

Deena Beverley

The saying 'when life gives you lemons, make lemonade/lemon drizzle cake/ Limoncello, etc.' could not be more apt here, although rather than the vibrant lemon-motif vintage fabric I used to back and self-border this piece, I'm referring here to a quality in the vintage tablecloth I used to make the front. I could not resist its graphic rose imagery in paintbox-bright colours as a background for my hand-drawn, painted and stitched image of Susie; it perfectly reflected her personality and her business, as a supplier of high-quality vintage pieces including a huge range of brooches, many featuring roses. So I started work on this large-scale piece without delving into its practical suitability.

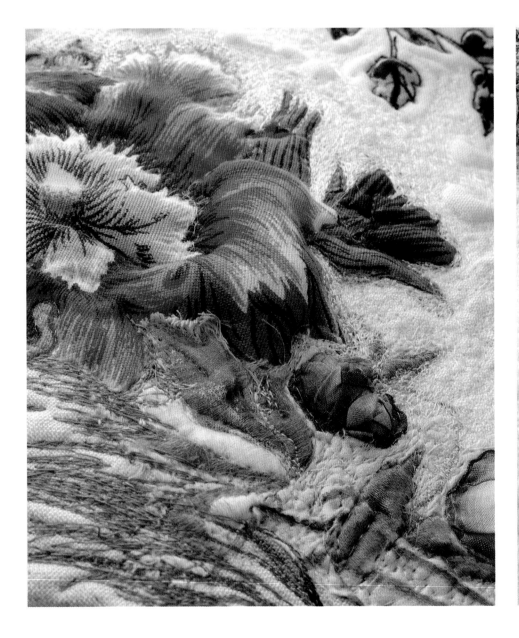

Unpredictable Fabrics and Going with the Flow

Below left: Heavily padded Trapunto quilting selectively accentuates vintage appliquéd elements.
Below right: Instinctive, intuitive quilting makes roses bloom on previously flat, featureless vintage cloth.

Intuitive quilting simply means quilting without a defined plan or pattern in mind. Here, the tablecloth on which I'd drawn, painted, appliquéd and embroidered my time-intensive main image proved to have been a far from ideal choice. Despite having been carefully basted in place, with basting stitches selectively removed as I worked up each area of the face, hair and floral head-dress, the tablecloth, bought as cotton, clearly wasn't. It's a 1950s cotton blend with a high rayon content, giving it a kind of natural 'slip'. When I started to intuitively quilt the background using free-motion embroidery, as I've done successfully many times before with natural fabrics, the top layer had a subtle yet definite creep to it due to the synthetic component, a motion that fought against the natural wadding layer in a most unhelpful way.

I had to take a deep breath and reframe my experience of making this piece, and I applied the time-honoured 'when life gives you lemons' approach. I decided to work with the movement of the top layer, and stop trying to control it. I relaxed my vice-like grip somewhat and allowed the surface fabric to pool and shift into the kinds of shapes it wanted to make. If the fabric puffed itself up into something even vaguely floriferous, I made it into a fully blown rose, or a bud. If a leaf form suggested itself by the way the fabric crept, I encouraged it to become foliage, adding a central, stitched vein if the leaf was pleasingly plump enough to warrant it.

As I worked, I considered my muse: her interests, her activities, and the central importance of her relationship with her twin sister. I also used the natural 'give' of the rayon to develop moon and sun motifs, speaking to the sisters' enjoyment of pagan festivals, jewel-like symbols to signify vintage accessories, and lots of hearts to symbolize the love that they have for each other, their family and friends, and their passionate approach to life; and two hearts beside each other, because they are twins, and very close. To emphasize these deliberately amplified raised areas, I free-motion quilted around them very intensively.

I'm not sure I'd choose this kind of fabric again for this kind of quilted pictorial piece, but everything is a learning experience, and if I ever find myself confronted with a slippery or expansive fabric that moves or grows beneath my touch when I stitch with it, I'll be ever so slightly less afraid. I hope having read this that you will be too. Embrace the movement. Go with the flow. It's not a bad mantra after all.

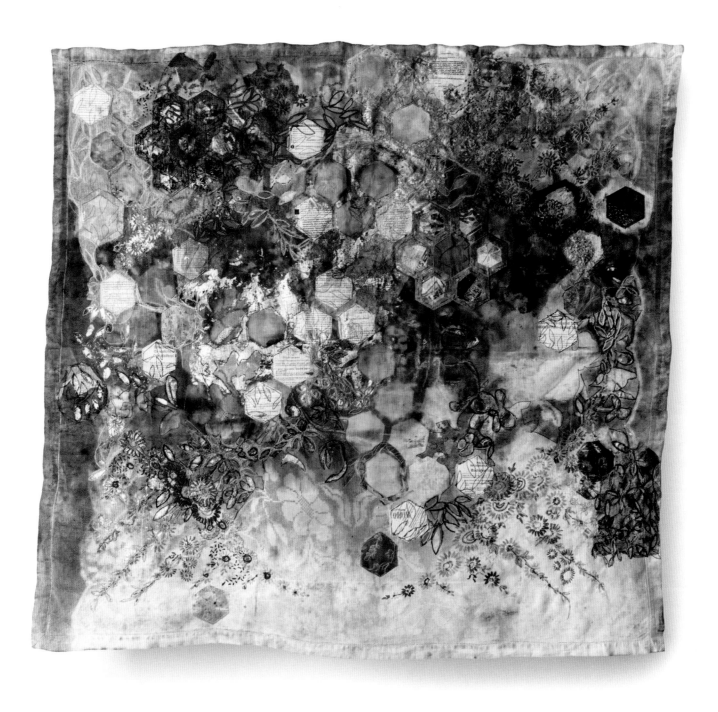

Above: '*Absence' (Cas Holmes). The pattern is informed by hexagons used in traditional quilt making. These have provided the templates for additional 'blocks' made from prescription papers and to block out areas of the dye from reacting in the sun printing process on page 101. The 'hexies' wander freely across the tablecloth background. 120 x 120cm (48 x 48in).*

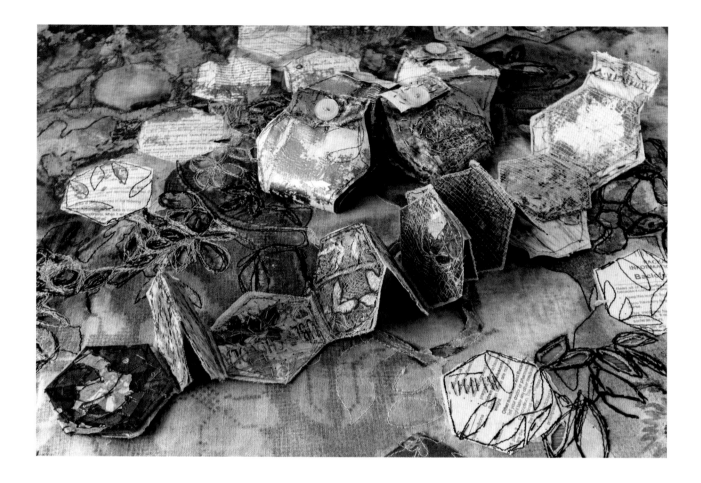

Absence

Cas Holmes

Fibre and Form, a Medway-based textile arts group, was gifted a red vanity case belonging to a local seamstress, Joan Wells, full of her beautifully worked patchwork pieces and a quilt in progress. The suitcase and its contents became the basis for our group exhibition, *Nice Bit of Stuff.*

Joan used materials she had on hand. The paper templates for her quilt were created out of domestic packaging, cereal boxes and magazines. These fragments from a past life became the foundation for another in the tablecloth series.

The hexagon is a recognized structural block in patchwork; it is also often referred to as nature's divine shape, a building block of the natural world found in the geometry and construction of beehives and in the cellular forms found in plants. In the creation of this work, 'Absence', the interior references I relate to are often found in the patterns of our domestic fabrics and are connected to my love of the shapes and forms of the exterior world of nature. (For more about the techniques I used, see Stencils and Sun Prints, page 101.)

Above: *Hex-books laying on a section of 'Absence' (Cas Holmes). Small book forms using some of 'leftover' hexagon cardboard templates utilized in their construction. These carry an imprint of the sun print from 'Absence' which can also be seen on the section of cloth on which the book sits.*

Sheilagh Dyson: Piecing Together

Below: *'Piecing Together'*
(Sheilagh Dyson).
Simple text hand stamped
in permanent ink,
transferred images and
further details of Joan's life
are combined with vintage
cloth and stitch. 40 x 20 x
2cm (16 x 8 x ¾in).

In her response to the red case, artist Sheilagh Dyson used Joan's vintage domestic dressing-table runners to create a book piece called 'Piecing Together'. As she describes:

'Although we'd never met, I grew to know Joan through family photographs and stories her daughter shared about her mother's fascinating life. I was keen to preserve some of Joan's patchwork 'flowers' with their nimble, densely packed stitching.

'Throughout, it was important to me to maintain the softness of the vintage linens and the tactility of the piece – a "hug in a book" – in tribute to this astonishing woman. Joan's hand-worked tray cloths and embroidery became pages, each one telling a different chapter of her life. Family photos were reproduced on inkjet printable cotton fabric, and touches of colour were added with dye-based pencils in a nod to the hand-coloured photography typical of the day.'

Stencils and Sun Prints

Cas Holmes

Harnessing a few hot summer days of sunshine, I created sun prints with silk dyes, using the hexagon templates alongside collated weeds and found objects from the garden as stencils to block the direct sunlight reaching the cloth. These improvised stencils resisted the colour being fully developed on the surface of the cloth.

1 Pin your cloth to a large piece of polystyrene or firm cardboard covered with plastic sheeting.
2 Dampen the surface with a spray of clean water before sponging and brushing on layers of diluted silk dyes. Allow the colours to bleed and run into each other for a blended palette.
3 Pin your cut-out stencil shapes and gathered plant materials in place.
4 Leave the cloth in the sun to dry and to set.

The heat from the sun set the dye, leaving a lighter area in the negative, or in 'absence', where the stencils and the plants were placed.

'Absence' was further embellished with medical wrappers and a selection of Joan's stitched 'hexies' and paper pieces, to create a 'disrupted' or 'broken' pattern in stitch. Small sections of the patterned cloth were cut out and removed to leave flower and leaf shapes. The resulting lace-like holes were outlined from the back of the cloth using a thick thread in the bobbin case, and further embellished with hand embroidery.

A Note About Machine Stitching

'Absence' is typical of many of my works where paper and cloth are combined structurally with machine and hand stitch to create a rich surface texture.

- When mixing paper and cloth, work with a topstitch or jeans machine needle: 100/16 or 90/14.
- Use good quality machine thread: 40/50/60 weight rayon, cotton or polyester (Aurifil, Gütermann, Madeira).
- Test on your materials to see how the machine responds.
- When working with free-motion stitch, practise first, so you know where your hands are going: follow a line of drawing or the writing of your name.

Above: *Sketch documenting work in progress for 'Absence' (Cas Holmes). The cardboard templates and stitched blocks provided the patterns and shapes to mask out areas in the sun-printing process.*

Kantha Kawaii

Deena Beverley

The impact of suddenly losing the studio and workshop complex I shared with my husband for almost 30 years cannot be overstated. It was unexpected, and emotionally and physically overwhelming as we struggled to reduce the tools, equipment and materials amassed over decades. We live in a doll's-house-sized, two up, two down terraced cottage, with no attic or cellar. Secure storage is expensive, so 10 per cent really was the absolute maximum we could keep. It was interesting in this forced exodus, what we chose to save.

Personal items came first: handwritten notes and drawings stuck to our studio fridge, family photos and sketchbooks. Tools and equipment for textile art, art direction and set building went into secure storage or were squeezed into our home. Our domestic possessions such as clothes had to be shunted aside to make way, and we're still struggling to unearth what got buried in this process, years later.

During these first 'mission critical' decisions, endlessly packing and loading under incredible duress, we found ourselves compulsively stuffing tiny rags and fragments of textiles into our pockets. In saving these fragile, apparently worthless things, perhaps we were valuing ourselves, having been inexplicably discarded not just from the buildings, but from the close relationships forged there. Whatever the reason, save them we did, and our longstanding passion for mending, as an essential part of our practice, deepened during the process of healing from this unwelcome, shocking abruption.

'Kantha Kawaii' was worked almost entirely in a coffee shop by day and a pub by night, at the local open-access community sewing bee I initiated in efforts to get myself out of the house. As the warmth of companionship and shared laughter slowly rubbed the sharp edges off the rawness of my pain, I began to feel able to use brighter colours and lighter subjects in my work, hence the 'kawaii' (cute) aspect, referencing a hesitant return to some kind of trusting child-like innocence. The little mouse mischievously regarding the larger creature at the centre of the piece speaks to

Right: A rescued section of a chair framed 'Kantha Kawaii' perfectly.

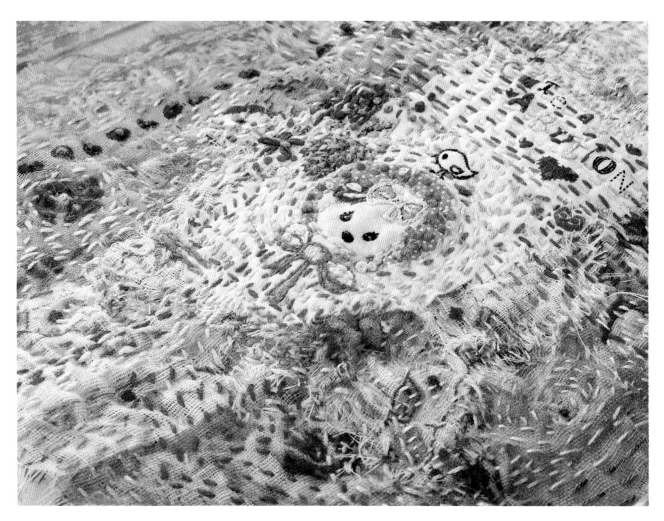

the David and Goliath aspect of us not only surviving, but beginning to thrive again, despite being profoundly fiscally disadvantaged compared to our old friends and landlords. The stitched piece is housed in a piece of salvaged vintage furniture from our store of such pieces, from which we have long made new work.

I finally got round to handwashing some of the ragged scraps we'd saved in those first, bleak wintry days of losing our studio workshop, for use in this cheerful new work. It helped on so many levels. The loss had knocked us sideways, severely denting our sense of self, but slowly, one stitch at a time, one tiny scrap of salvaged cloth at a time, the colour was returning to our lives, to ourselves. I was sewing myself whole again, making something new from whatever I'd been able to save, and turning it into a new cloth of life.

Above: *Detail of 'Kantha Kawaii' (Deena Beverley). Found fabric rags and threads.*

Right: *You can see the beautifully weatherworn original paint of the chair frame.*

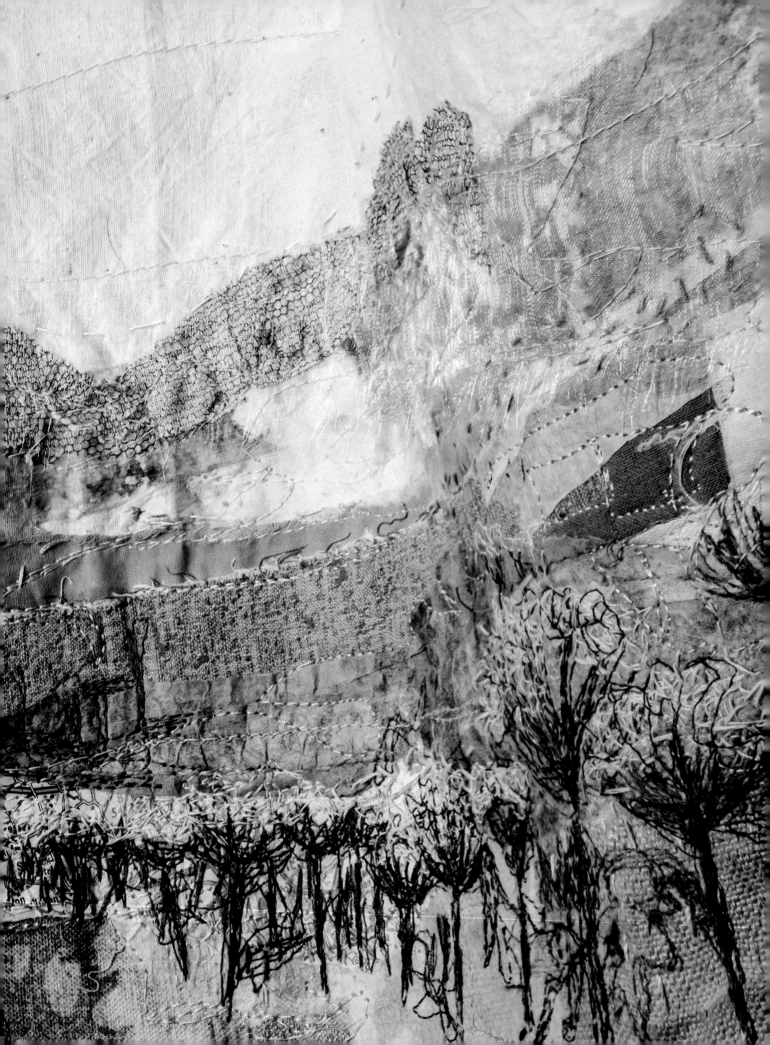

Nature
to
Nurture

Left: 'Walk in the Park'
(Cas Holmes). Paper,
cloth, paint, machine and
hand stitching have been
worked together to create
a 'borderless' piece.
270 x 25cm (106 x 10in).

Nature to Nurture

Countless studies have documented the positive impact of nature on physical and mental health. From 'forest bathing' (shinrin-yoku) to simply staring out of a train window as the urban sprawl melts into undulating fields, there's something deeply restorative about consciously connecting with nature. Nature heals. It's that simple. Whether your access to the natural world is limited to appreciating the flowers that spring up in the gaps in an inner-city pavement, or you're fortunate enough to live by the ocean or other wide-open space, nature, like love, really is all around, and like love, it's worth appreciating.

'To sit in the shade on a fine day, and look upon verdure is the most perfect refreshment.'

Jane Austen

Below: *'Stringing Rhubarb' (Deena Beverley). Ink, paint and embroidery with rhubarb cordage.*

Rhubarb String Making

Deena Beverley

Appreciation of whatever aspect of nature it's possible to access extends into my everyday art practice. Making rhubarb into a comforting dessert presented a golden opportunity. Prepping the jewel-bright stems on a board near my sewing and drawing equipment, I set the strings removed from the rhubarb aside to dry slightly, before turning them into beautiful pink cordage.

Method

1 Pare back rhubarb's fibrous outer layer, producing long strands.
2 Some strands will already be fine and string-like. Carefully ease apart strands resembling wide satin ribbon to make slender strings. Rub away any remaining densely fibrous areas.
3 Leave separated strands on a flat surface in a single layer to dry for two hours.
4 Bend one strand in half. Twist gently at the halfway point until it turns onto itself. Taking the strand behind this turned centre point, continue to twist it, approximately three times. Bring it towards you over the other strand.
5 Continue this reverse twist. Add other strands by placing across the two existing raw ends as you work.

Here, I've produced a mixed-media still-life piece in gratitude to simple pleasures I can still access through nature, despite not being able to easily walk in it. I've couched my rhubarb string onto my drawn and painted image of the rhubarb which yielded it, alongside the knife used to pare the fibres from the stems, rendered in fabric collage cut freehand from eco-dyed fabrics, supplied by a friend.

An Ever-Changing Relationship to Nature

Cas Holmes

'We still do not know one thousandth of 1 per cent of what nature has revealed to us.'

ALBERT EINSTEIN

Our relationship with nature is ever-changing and complex. Every part of the natural world, from the gardens on our doorsteps to the wild open spaces, is affected by human influence. Through the exploration of familiar places, I learned to value the comfort I get from being outside and engaging with the natural world, yet equally witness the damage we are capable of doing. I am constantly balancing the growing of vegetables in our small garden with just enough weeding to be able to take delight in the small wild flowers that fill the space left. We allow for 'nature' but on our terms.

Aside from the health and emotional benefits of exercise, being 'out in the world' informs my work. The regular walks I take in Mote Park and surrounding green spaces provide moments of respite and inspiration now that my world has geographically shrunk. I often stop to sit on a bench with a flask of tea, to draw and take notes.

These 'micro-adventures' in nature provide stimulus as I record the changes during the year, or simply sit and take in the woodland calm the trees offer on a hot day. A sketchbook and camera are useful tools that enable us to navigate our smaller spaces with a sense of curiosity and purpose. Even familiar, well-trodden spaces can yield new experiences in which we can see something different. An interesting note: Mote Park's name comes from the Old English word 'moot', meaning 'meeting place', indicating that the area used to be of great administrative importance. The park is still used as a place for meetings today, from music, sports and fairs to informal gatherings of family and friends to picnic and play.

Left: *Detail of 'Walk in the Park' (Cas Holmes).*

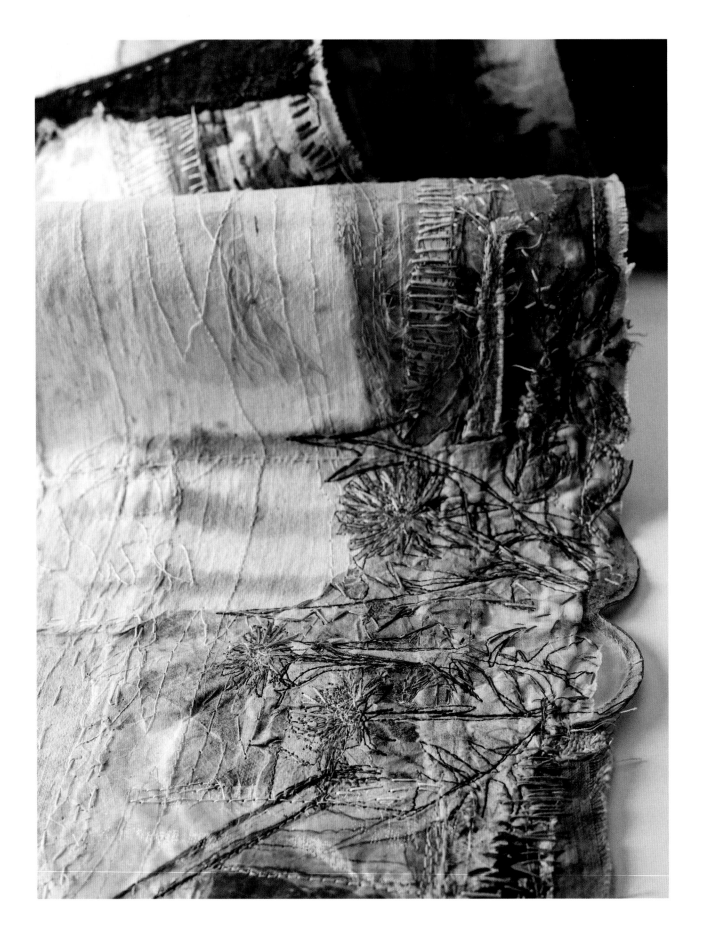

Walk in the Park

Cas Holmes

'Walk in the Park' reflects the small discoveries found along the shady footpaths and 'hidden edges' of nearby Mote Park. I often stop with a sketchbook in hand to make studies of the changes I see through the year, from the early flowering of bright yellow dandelions, a rich source of nectar for waking bees, to the white lacy caps of the cow parsley. I carry memories of my Romani grandmother instructing me about the value of edible plants and their use in herbal medicine. The leaves and petals I gathered as I walked provided the colour for some of the threads and cloth used in the creation of this work. Caroline Zoob, writing in *Stitcher's Journal* in September 2021, describes the piece:

> '*It is in the form of a long mixed-media scroll pinned to the wall such that some of it curves towards the viewer before looping back, rather as one might meander around the bends in a path. The starting point is Cas's garden studio, and throughout the length of the scroll, different times and moods are reflected...It is not a work to be confined within a mount or frame, and so it seems to float, as one feels the sky above and the earth below.*'

To dye some of the cloth used in 'Walk in the Park', I immersed some of the gathered flower heads and other plant material in a pan containing one part white vinegar and three to four parts water. The pan was brought to a boil and left to simmer for an hour before being set aside to cool overnight. I gently washed the cloth afterwards by hand. Pieces of both painted and dyed cloth are overlaid along the bottom of a length of linen to suggest the path against the sky-horizon line. Text, maps and other found materials are worked into the upper layers, to which more detailed studies of plants and trees have been added.

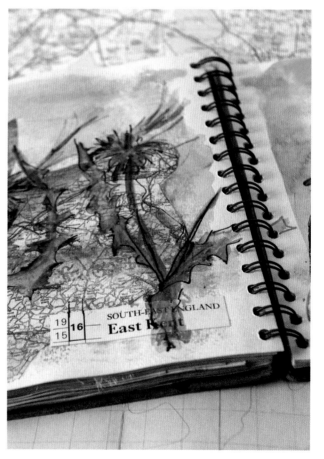

Allan Brown: The Nettle Dress

Deena Beverley

The lockdown response to the global pandemic saw many people appreciating, sometimes for the first time, the value of the natural resources close to hand. They spent more time in their own gardens, and took local daily walks permitted for their physical and mental health. As the pandemic eased, this increased interest in the natural world and its manifold benefits continued to develop as people realized its potential for healing and sheer visceral enjoyment.

A groundswell of appreciating nature's bounty in terms of natural dyes, as eco-printing materials and as a fibre for textile art, grew as virulently as the nettles that inspired textile artist Allan Brown. He spent seven years creating fibre that he wove into cloth, which he made into a dress, immortalized in Dylan Howitt's beautiful film, *The Nettle Dress*. He even spun the three-ply thread that he hand stitched the dress with, adding two strands of his allotment-grown flax to make the thread strong enough for constructional stitching of a garment designed to be worn.

Opposite: *Textiles produced literally from the ground up; foraged nettles provided fibre for Allan Brown's hand spun, woven and sewn nettle dress fabric, and even the thread with which he stitched it.*

Below: *Natural dyes offer a joyful rainbow palette brighter than might be generally imagined possible. Colour library, Allan Brown.*

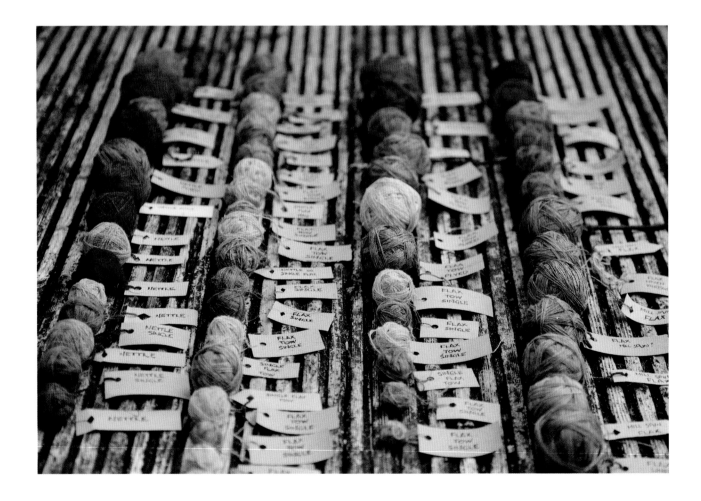

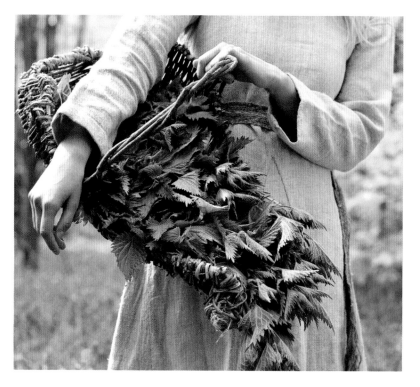

I became aware of Allan's work as news of the film spread on social media. Clearly, there was an almost alchemic potency to this story that far outweighed any written synopsis. People shared their experiences of watching the film, initially a limited indie release, with the kind of ardour usually reserved for long-awaited sequels in a blockbuster movie franchise. Manifestly, there was magic afoot. I sought out a cinema showing the film, to understand what was driving such impassioned mainstream reviews.

I anticipated an uplifting tale of a man finding solace in nature during a time of great loss: Allan's wife and his father had both died during the making of the dress; a project which evolved as Allan sought and found comfort in every aspect of working with nettles. What I hadn't expected was to be mesmerized by cinematic images of working with nature-based textiles, so that the painful human story subsided in my consciousness with all the lightness of touch of the exquisite, almost breath-holding sequence of a nettle puffing out its pollen spores across the screen, to a quietly enraptured audience, virtually meditating in unison.

I had gone in expecting a meditation on living beyond loss, and I emerged having become fully immersed in a gently uplifting and deeply inspirational reminder of the power of nature to heal and to connect, in this instance, in a spellbound shared silence.

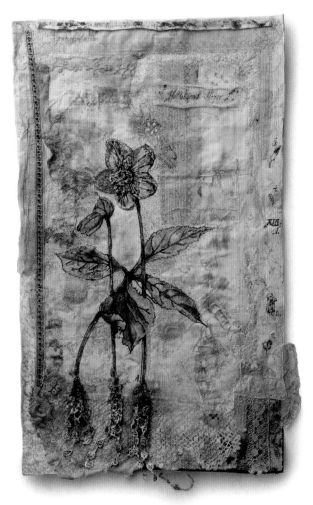

'Photography is an
immediate reaction,
drawing is a meditation.'

HENRI CARTIER-BRESSON

The Mindful Magic of Botanical Drawing

Deena Beverley

Flowers are important in supporting my mental health and emotional wellbeing, and the first thing I do daily is go outside to look at the plants beyond my door. In nice weather, I don't want to be inside. Our tiny cottage is dark and claustrophobic. Mobility issues preclude the kind of walking in nature I'd love to be able to do freely, but even at home I can perch on my mobility trolley and draw, and lose, or perhaps find, myself in the process.

Conventional mindfulness techniques that work for many people – measured breathing, progressive muscle relaxation, etc. – make me feel worse; horribly conscious that I'm desperately chasing away anxiety, which intensifies the feelings I'm trying to escape.

Happily, calm is just a pencil stroke away as drawing, or more to the point, really looking in an intimate, quiet communion with nature, enables me to be more present in the moment; less caught up in vacillating between anxieties about the future, ruminations about the past, and current situations beyond my control.

The psychotherapeutic expression 'action displaces anxiety' is apt. It's near impossible to focus simultaneously on drawing a petal so tremulously windblown that it might not be in situ when you look up from your sketchbook.

Don't worry about the end result. Achieving a 'flow' state is the aim. An enhanced sense of calm is the result you seek, not a 'perfect' drawing. Perfectionism is overrated, and not always helpful.

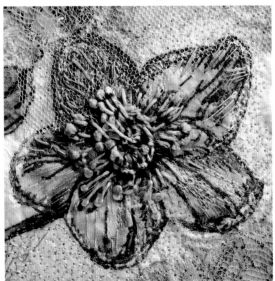

Above: *'Invincible' (Deena Beverley). Ink, paint and embroidery with collaged papers and found fabrics.*

Practise the Art of Mindful Drawing

Below: *Botanical drawing and painting. Achieving a flow state in drawing is more important than a perfectionist approach to the end result. Make enjoying the process your primary aim.*

- Engage with what you're drawing: draw what you can see, not what you think you can see.
- Cultivate a habit of carrying a slim, pocket-sized notebook and your preferred mark-making tool for fieldwork: I use inexpensive passport-type notebooks and waterproof pens bought in bulk, so I can afford to have them in every coat pocket and bag.
- A phone is great for recording, but is no substitute for drawing from life. If you can't get out into nature, bring flora indoors; this connects you with your subject in an entirely different way than drawing from screen references.
- A soft pencil dances lightly across the surface of the page and doesn't feel as intimidating as a hard one, which gouges into it: 2B pencils gently encourage confident mark making.

Use whatever's to hand to make marks, to create and continue the dialogue between you, your subject and the surface. On a recent outing, I encouraged young family members to draw in the muddy

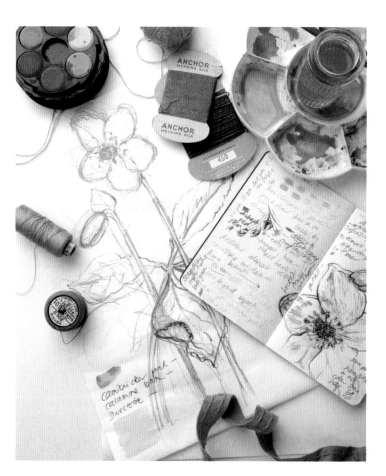

surface of a car park using found flints lashed to sticks with marram grass. Their joy at the haptic physicality of the experience was infectious and soon the adults were joining in.

Resist the temptation to erase 'erroneous' marks. Lay down new lines. Keep looking at your subject and back at your paper. Between the two, you have all the information you need to make an accurate drawing. Accept that you'll need to keep adjusting. As a metaphor for life, it's no bad thing, and all part of why drawing can be so calming.

If you don't have access to true-to-life colours, use what's to hand and make notes about the actual colours for future reference. For this field notebook study, I used some random dried-up felt pens from my shed, which is where I drew this, sheltering from a sudden deluge. I later translated the sketch into a richly layered, painted, drawn and free-motion embroidered piece using found materials, emphasizing some areas with hand embroidery in vintage threads.

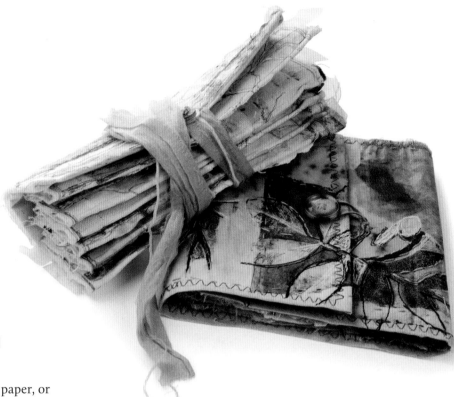

Folding Books:
A Collaboration

Made from one length of cloth or paper, or joined sections, the scroll or folding book is a useful form in which to tell a stitched story; versatile for projects individual or collaborative.

Theme

Edo-period Japanese travellers often recorded their adventures in scroll or orihon (accordion book) form, including poet Matsuo Bashō's popular *The Narrow Road to the Deep North*. Our books evolved from discussions around our own '*Narrow Roads*'. Cas's book reflects walks among her local poplars, while Deena's pays homage to poplars summarily excised from the view from her cottage window. Deena remarks: 'Mobility and balance issues limiting my access to moving freely in nature, this loss was impactful, having bought my home primarily for the poplar view, and their lyrical, swishing sound.'

When expanding on your theme, consider exchanging prompts in the form of words, voice notes, images, music and memes. As Cas explains: 'Ideas about the book would often flow into my mind when out walking, or as I stopped to draw. My thoughts became voice notes recorded on the phone, or quickly sketched, as we discovered how poplars played a role in our individual stories.'

Materials

We enjoy using a range of cloth, paper and more. Firm papers add rigidity, worn cloth and flimsier papers, flexibility. 'Material' is what you make it; fragments of gleaming sticky tape clinging to a used envelope add sparkle to an otherwise matt rendering of tree bark, for example.

Opposite above: *'Poplar Eulogy' (Deena Beverley). Folded book; ink, paint, and stitch on found papers and fabrics.*

Opposite below: *Pale, spectral shades reflect the poplars felled in the land viewed from Deena's cottage, now visible to her only in her mind's eye.*

114

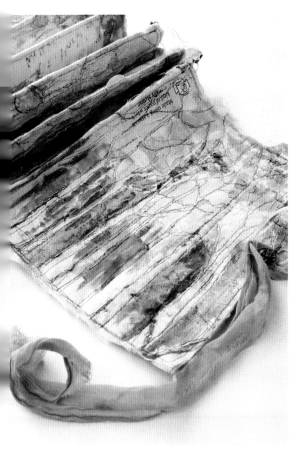

Structure

- Consider who'll provide materials, whether they can be rejected, must be incorporated; whether others can be added.

 Creating a collaged surface, Deena inadvertently transferred Cas's handwritten text from an envelope of materials she'd sent, onto her background. 'I left this asemic text visible, a serendipitous reference to postage difficulties faced in production.'

- Consider how defined the format is, whether there are limitations to size, shape or format – scroll-like, stitch-bound, folding or something else.

 We left these considerations open-ended, settling independently on a zigzag format, making a book conveniently small to store which can be opened for plinth display, or wall hung: versatile for exhibiting artists.

- Consider the methodology's definition: whether you're confined to stitch, or if glue is allowed. As Deena states:

 'We'd gained enough confidence in our collaborative process by this time that bindings and methodologies weren't discussed. An atmosphere of trusting creative endeavour had become embedded. When I saw our independently made, co-developed books placed together for photography, it was a powerful moment. I felt it important to photograph them separately too, honouring our individual voices alongside the dual, harmonized voice in the book-shaped spaces we'd created in this book as a whole.'

Deena Beverley

My tall, thin book echoes the elegant verticality of the lost poplars. The instability of the finished, standing book references the uncertainty associated with poplars planted as woodland. Planted as a 'cash crop', poplars can be felled without notice. Like my cloth book, and me, they can be upright one minute, horizontal the next.

Since, years on, I still feel protective of these lost trees, I enfolded the book within a cover which wraps around this 'forest for myself' like an embrace, closing it with silken ties left overlong to add protective double encircling. My book is robust yet soft, alluding to the strength and vulnerability of the trees.

I used fragile materials; echoing my own sense of personal jeopardy. The book became an illustration of circumstances threatening my equilibrium, and a talismanic totem of self-protection; attempting to cocoon and insulate myself from things beyond my control. The work spoke for me, at a time when I found overt communication challenging.

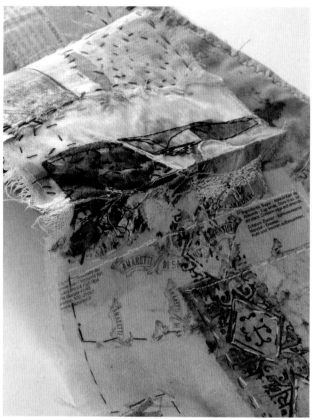

Trees Sometimes Stand Alone

Cas Holmes

My book echoes the trail along Mote Park's wooded valley, where I take short walks. A gate between the poplar trees at the park's edge is a magical portal, allowing me to enter briefly to breathe in nature during days busy with carer responsibilities. Collected leaves, and a print from a custard cream dropped while having a cuppa, are captured in stitched cloth and paper. As the sun set upon the ever-changing grey-purple turn of day into night, I thought of walks taken in other landscapes.

Mote Park lost many trees in 1987's great storm. Wide gaps appeared between the trees, allowing views of the Len Valley. One poplar tree stands alone; branches spread as if trying to connect with its neighbours. Often, during times of walking alone, I'd dwell upon ways of reaching out and connecting to others in a world I could no longer navigate with ease. Memories of friendship in faraway places are bound into the covers with every stitch.

'Solitary trees, if they grow at all, grow strong.'
WINSTON CHURCHILL

Above: *'Trees Sometimes Stand Alone' (Cas Holmes). Disperse (transfer) dyed cloth, prints from found objects, machine and hand stitch. When open, approx. 100 x 15 x 7cm (39 x 6 x 3in).*

Michala Gyetvai

Deena Beverley

Michala Gyetvai had my local textile and stitch group enraptured when reading aloud the poetry she writes in tandem with making large, sumptuous, nature-inspired textile pieces. Painting and sculpting with threads, she stitches and layers, producing powerful, elemental pieces, which undulate as much as the natural world that so inspires her.

Michala's intimate contact with landscape, revealed in poetic childhood recollections, drives her work, as she explains: 'Often my poems become a title, showing a journey of thoughts, emotional autobiographical layers, which become a tangible reality… transformed into landscapes…drawings, textiles or paintings.'

We connected over her elegiac poem 'The Elms', as at this time I was working on my 'Poplars' piece, a collaboratively devised project in which Cas and I explored our relationship to trees in our respective localities, and mine, too, was based around a sense of loss.

My favourite piece of Michala's was not a textile one though, but the inside of a lid of a cardboard box holding textile brooches for sale. The monoprint image of a weeping woman that Michala had cut from card epitomizes soulful art to me.

'When the elms perished
I saw giant skeletons
Like cracks gouged in the sky
And all I could do was cry…'

FROM 'ELMS' BY MICHALA GYETVAI

Below left: *Cardboard monoprint block for 'She Cried with the Trees' (Michala Gyetvai).*

Below right: *Textile landscape; mixed fibres on a found wool blanket.*

Made in Norfolk: A Triptych Worked Together, Apart

Deena Beverley

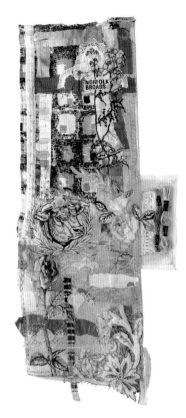
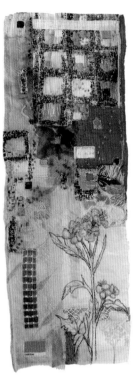
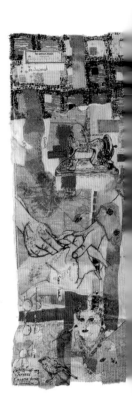

Cas and I were both born in Norwich, attending Yarmouth Art College years apart; discovering this decades later. We connected over cloth, paper and stitch; our author/artist journeys determining one day we'd work together.

Separated by geography, schedules, and challenging circumstances, we considered opportunities for collaboration for practicality and fair representation of our experiences and artistic voices. We chose a classic triptych form: two autonomous sections, the third passing between us. Through dialogue, we discovered our 'together, apart' paths ran in surprisingly similar parallels.

Mustard, part of our heritage, became so significant our working title became 'Mustard'; a codicil to 'Made in Norfolk'.

For me, Colman's Mustard and its iconic bull logo recall my grandmother running her own butchery on the side of Norwich where I lived as an adult, near the football ground and Colman's. Nostalgia fuelled, I sent an image of Colman's Mustard seed kit packaging to Cas, and we gifted each other the kit.

For visual cohesion, I prepared three layered backgrounds for us both, creating layers of my vintage fabrics and found papers. I also included the envelope in which Cas supplied fragments of cloth for inclusion. Some layers of symbolism and memory in our cloths are recognizable; others are known only to each maker.

My 1950s geometric fabric evokes a fondly remembered schoolfriend's prefab home. Mustard and green are Norwich City Football Club's colours: the Canaries, nicknamed after the 16th century Huguenot weavers, influential in making the city a textile manufacturing centre. I included a canary in the 'working together, apart' cloth, and drew my great-grandmother's treadle sewing machine in ink on found fabric, acknowledging the love of stitch Cas and I share, and paying homage to our grandmothers, important figures in our lives. The purple-haired figure represents a pivotal moment in my life, and Norfolk lavender.

My own cloth, dense with imagery meticulously placed to enhance meaning, is a keeper. It will hang in my garden studio, reminding me of the people and places who've helped me become who I am. Made in Norfolk; proudly so.

Above: *'Made in Norfolk'. Triptych by Deena Beverley and Cas Holmes. Ink, paint and stitch using found papers and materials.*

Opposite above: *Mustard flower detail (Cas Holmes).*

Opposite below: *'Bull, Close' (Deena Beverley). Hand drawn in ink on found fabrics, with embroidery.*

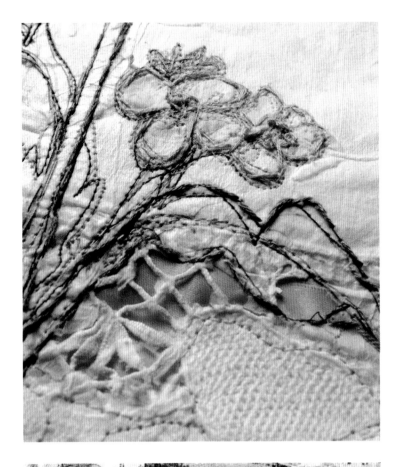

Made in Norfolk: Mustard Flower

Cas Holmes

My response to the rich assortment of vintage cloth unfolding from the large brown packet that Deena sent through the post was visceral. The tightly-bound outer wrapper hid a rich gold interior lining, immediately bringing back memories of early morning sunshine on Mousehold Heath in Norwich, where I grew up. Like Kett, who raised a rebellion against the land enclosures act from his camp on the heath's famous hills, in a small act of my own rebellion, I made a start on the project. My eyes lighted upon on a beautifully illustrated box of mustard seeds Deena had kindly gifted me, so I grabbed some colours to paint the yellow mustard flowers that reminded me of the bright yellow fields of Norfolk.

The practical work stimulated our discussion about the individual memories we hold of Norfolk, and our home city of Norwich. I recollect being told that my great-grandparent's family worked at Colman's Mustard factory in Thorpe Hamlet, where I went to school and first encountered cross stitch in the making of what I referred to as the 'dreaded cookery apron'; unfinished. Deena recalled making the same 'dreaded apron', hers also incomplete. My Mustard Flower (centre) panel contains happier renditions of cross stitch, connecting the vintage geometric patterned cloth Deena supplied, to the yellow and gold of mine.

Over 50 years later, these hands have determined to find their own way to 'do different' with stitch, as we say in Norfolk and have been carefully rendered in straight stitch on the collaboratively, independently worked panel (right) in relation to Deena's beautiful illustrative work paying homage to her great-grandmother's old Singer, speaking of the machine and hand stitch running soulfully through our work in the creation of these panels (see image on page 5).

Reflections and Findings from 'Made in Norfolk'

Deena Beverley

'There is only one thing that makes a dream impossible to achieve: the fear of failure.'

PAULO COELHO

Starting points for collaboration are everywhere. The important thing is to start them at all. As soon as Cas and I decided to produce collaborative pieces for this book, they took on a life of their own, long before they were 'officially' discussed and evolved. In fact, this 'life of their own' very much typified the production of this entire book, created as it was during particularly challenging times in our lives, making meaningful collaboration across the miles even more difficult than usual. All that we determined at the outset was the number of projects: three, as being a workable number. These were the stitch sampler (pages 34–35), Poplars (pages 114–115) and the triptych on the preceding pages, 'Made in Norfolk'.

First, find a collaborator; a friend, in real life or online, a colleague, a member of a group common to you both, or set up a group specific to the collaboration and extend the invitation to multiple participants, as Liesbeth Werts did with her innovative and popular UMO (unidentified meaningful object) project to which Cas and I responded (see page 90).

Reach out to a fellow creative whose work inspires you. People are often flattered to be asked to be a creative collaborator. You might get some rejections along the way, but also some pleasant and productive surprises. The key is simply to begin. You never know what's possible until you try.

Right: *Detail of 'Made in Norfolk' panel by Deena Beverley. Collaged background of ink drawing, paint and embroidery using found fabric and paper. (Gold joss paper supplied by Cas Holmes.)*

Opposite: *The back of the vintage geometric curtain fabric supplied by Deena feeds into the bright yellow and orange cotton cloth Cas collected while studying in India.*

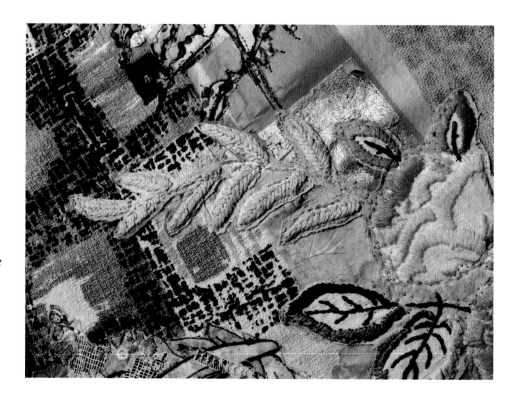

Establishing the Project

- Keep things simple at the outset and throughout. Clarity is key.
- Decide a deadline. Ours was self-explanatory as we had a photography deadline for this book.
- Decide the format. We decided on a triptych for the reasons described on the preceding pages. I sketched the size and shape of the individual panels to enable easy sending to each other and easy storage between exhibitions, but still large enough that when they were displayed together they would make a sizeable visual impact in a gallery space.
- Decide on materials. I offered to source materials from which we made the three backgrounds, as at this point I had the time available to produce them and my collection of vintage fabrics and ephemera perfectly suited the subjects which had evolved during our discussions about this piece in terms of pattern and era.
- Decide how you will continue to exchange and share materials, inspiration and information as the work evolves, and any changes needed to the process as it develops.
- Consider stitch processes and technique, whether to limit these or leave them open-ended. We broadly agreed that the hand and free-motion stitch methods we used in response to the materials would be allowed to evolve naturally, though we'd keep the stitching simple, e.g. running stitch and French knots, both because these are our favoured methods and to retain some visual unity.
- Consider the first stages of the project, whether each person will contribute and then exchange work, or if one person will kick start the project, as here, in my preparation for the layered backgrounds to help make the triptych visually cohesive.

More Thoughts on Creative Collaboration
Cas Holmes

The process of creating individual works in response to an exchange of materials can be adapted to provide stimulus for different ways of working in collaboration with other makers. Here are a few suggestions:

- Create a response to the same source material (the hexagon project for the *Nice Bit of Stuff* exhibition on page 98 illustrates this).
- Use neutral coloured cloth, such as linen or calico, and start with a stitch response to the cloth before incorporating the stitched cloth into a work (e.g. patterns and texture in straight stitch).
- Dye or stain the same cloth with colour and share in a small group to be added to a project.
- Limit the number of pieces or the colour of cloth to be used within each section of the collaboration.

How was it for me?

Deena Beverley

Working on this book, my husband and I had unexpectedly lost the extensive studio workspace we'd shared for 30 years, and were struggling to self-build a garden studio on a steeply sloping site with only pedestrian access. Due to health and mobility issues, progress was slow, painful and fatiguing. We needed to work to survive financially, and had carer responsibilities and other challenges. I often signed off emails to Cas with 'It's a lot!'

I minimized phone and Zoom calls to filter out the 'incoming', retaining my focus on planning a book written by two geographically distant people, on different schedules, multitudinously challenged. Lack of direct contact was as difficult for Cas to navigate as I found its alternative. Voice notes proved a brilliant tool in ameliorating this.

Carving out pockets of time in which to create collaboratively conceived textile pieces was difficult, without access to a dedicated workspace, tools and materials. However, these pieces, while initially giving me an unnerving sense of additional responsibility, proved surprisingly joyous. They provided a much-needed shot in the arm of alternative 'Vitamin C': 'Colour and Companionship'.

These collaborative pieces often 'showed their faces' in the midst of chaotic, disconnected times in my life; turning up like a friend you bump into at the supermarket; feeling you have no time, energy or inclination to stop and socialize, they make you feel so much better for having spent precious moments in their company. I loved seeing these pieces evolve as we both worked on them individually, at different times, in different places.

Honouring how they were worked, when art directing their final photography, I ensured they were shot independently and together; as they'd been created. Jointly conceptualized, independently worked, yet empathetically harmonious, seeing them together gave me confidence the symbiosis I'd hoped would run through this book, like lettering in a stick of Yarmouth rock, is writ clear.

'Onwards!' is my favourite self-motivating mantra. 'Dew Yew Keep a Troshin' is the Norfolk version. Creating this book with my fellow Norfolk Broad, Cas Holmes, has been my most challenging book title to date, but also, perhaps because of the intensity of effort required to surmount its hurdles, my most rewarding.

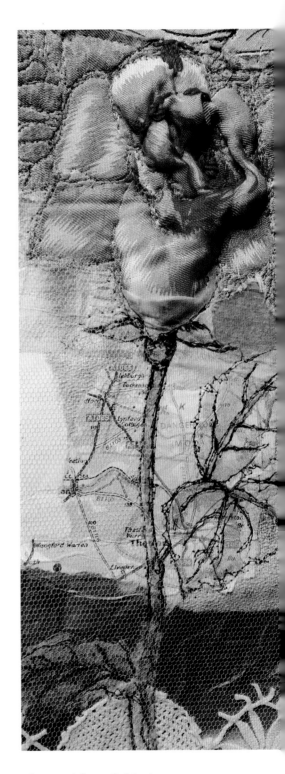

Above: *I 'planted' this vintage rose in 'Made in Norfolk' in homage to my mother.*

How was it for me?

Cas Holmes

Being out there, working with people and travelling to different places has been a huge part of my life and my practice. The last few years have seen this life that I value so much being eroded away as I struggle to cultivate the space for me, the artist, out of the day-to-day needs of being a carer.

I miss the face-to-face contact and sense of connection that come from working collaboratively on a project. Co-authoring a book with Deena presented its own challenges and equally gave moments of deep connection and pleasure. Separated by distance, and by the pressure that our individual circumstances placed on our time and energy, voice and text messages, like ships sending their signals in the night, provided a thread of communication to connect us and our thoughts. We worked out a path to the middle space, despite the various challenges we faced. Walking in the morning was an important time for me to think, as the middle of the night messages I found in my inbox were for Deena. What at times appeared impossible became possible.

It was when we worked on the stitch collaborations that I felt truly connected to Deena creatively. The fragments of cloth and accompanying notes that came through the post (and at times were lost) fed into the work, and built on our trust in each other and in our process.

Writing collaboratively on a book requires 'letting go' and learning to let the words 'dance' together. Sometimes we moved as one, and other times, one or the other would take the lead. It was a shared path, one that I was happy to walk with Deena, even if at times we were uncertain of which path we were taking. At times, the waves beneath what Deena referred to as our 'Good Ship Soulful Stitch' became a little bumpy. Sharing in the creation of this title has been an intellectual and creative challenge driven from the heart.

Above: *Detail from 'Made in Norfolk' (Cas Holmes).*

Contributing Artists

Jake Annetts	Instagram @the_thread_man
Melissa Averinos	yummygoods.com
Nathalie Banaigs	Instagram @nathaliebanaigs
Deena Beverley	deenabeverley.com
Allan Brown	facebook.com/HedgerowCouture
Clarissa Callesen	clarissacallesen.com
Sheilagh Dyson	facebook.com/SheilaghDysonArtist/
Mair Edwards	facebook.com/NewburyCreativeStitchers
Susie Ford	etsy.com/shop/ItsDecoDarling
Louise Gardiner	lougardiner.co.uk
Shelly Goldsmith	shellygoldsmith.com
Michala Gyetvai	michalagyetvai.co.uk
Cas Holmes	casholmes.uk
Vanessa Marr	domesticdusters.wordpress.com/
Anastasiia Podervianska	jyvopis.blogspot.com/
Jo Smith	Instagram @josmithtextiles
Sue Stone	womanwithafish.com/
Liesbeth Werts	facebook.com/liesbethwertstextileartist/

Websites

arttextilesmadeinbritain.co.uk	British textile artist group
canterburymuseums.co.uk /the-beaney	Beaney House of Art and Knowledge
carolinezoob.co.uk	Stitcher's Journal
dylanhowitt.com	Dylan Howitt: The Nettle Dress Filmmaker
embroderersguild.com	The Embroiderers' Guild
facebook.com/Newbury CreativeStitchers	Newbury Creative Stitchers
marchmonthouse.com	Marchmont House
nettledress.org	The Nettle Dress
quiltart.eu	European Quilt Art exhibiting group
quiltersguild.org.uk	The Quilters' Guild of the UK
romaniarts.co.uk	Romani arts and cultural website
royal-needlework.org.uk	Royal School of Needlework
textileartist.org	Textile art and artists
textilesandstitch.co.uk	Textiles and Stitch around Marlborough
vam.ac.uk	Victoria and Albert Museum
westdean.org.uk	Courses in textiles and other subjects

Suppliers

Explore your local hardware and DIY shops for paint, glues, fittings and equipment. Local art and hobby shops, supermarkets, charity and second-hand shops are full of wonderful alternative stuff to work with. Accept gifts or donations of materials from friends and colleagues... You never know what you might find to use and share in the 'gift' and what new project it could lead to. Re-use where possible.

UK

Colourcraft (C&A) Ltd (manufacturer of dyes, fabric paints and Brusho® and distributors of a wide range of materials including dyes, Koh-I-Noor paints and glues mentioned in the book)
Unit 5, 555 Carlisle Street, Sheffield S4 8DT
www.colourcraft.uk

Ernest Wright Scissors and Shears (supreme quality handmade scissors)
58 Broad Ln, Sheffield S1 4BT
www.ernestwright.co.uk

George Weil (art and craft supplies)
Old Portsmouth Road, Peasmarsh, Guildford
www.georgeweil.com

Rainbow Silks (textiles supplier)
6 Wheelers Yard, High Street, Great Missenden, Buckinghamshire HP16 OAL
www.rainbowsilks.co.uk

Whaleys (Bradford) Ltd (textiles supplier)
www.whaleys-bradford.ltd.uk

Woven Monkey (digital printing on fabric)
Unit 2. Winster Park, Corporation Road, Ilkeston, Derbyshire, DE7 4BN
www.wovenmonkey.com

USA and Canada
Dharma Trading Company
www.dharmatrading.com

Pro Chemical and Dye Inc
www.prochemicalanddye.net

Quilting Arts
www.quiltingdaily.com

Australia
The Thread Studio
www.thethreadstudio.com

Inspirational Places to Visit

Avebury Manor (National Trust)
Avebury, Marlborough, Wiltshire, SN8 1RD
Holds embroidered work by Deena Beverley and embroidered work facilitated and led by Deena Beverley working for the BBC and National Trust in collaboration with the Embroiderers' Guild, the Royal School of Needlework and local schools, colleges and community groups.
www.nationaltrust.org.uk
avebury@nationaltrust.org.uk

The House of Smalls Art Gallery
Innovative independent art gallery with regularly changing imaginatively curated group and individual shows.
www.thehouseofsmalls.art

Recommended Reading
and Resources

Beverley, Deena, *Brilliant Bags*, Mitchell Beazley, 2006

Beverley, Deena, *Embroidery 200 Questions Answered*, Search Press, 2011

Beverley, Deena, *Flowercrafts*, Lorenz Books, 2003

Beverley, Deena, *Freeform Embroidery: 200 Q&A*, Petersons Guides USA, 2011

Beverley, Deena, *New Crafts: Stringwork*, Lorenz Books, 1998

Beverley, Deena, *Traditional Needle Arts: Ribboncraft*, Mitchell Beazley, 1997

Blackburn, Julia, *Threads: The Delicate Life of John Craske*, Jonathan Cape, 2015

Cohen, Leonard, 'Anthem from The Future' (album), 1992

Corbett, Sarah, *A Little Book of Craftivism*, Cicada Books, 2013

Corbett, Sarah, *How to be a Craftivist: The Art of Gentle Protest*, Unbound, 2019

Eisenstein, Bernice, van Pelt, Robert Jan and Mitchell, Michael, *Memory Unearthed: The Łódź Ghetto Photographs of Henryk Ross*, Yale University Press, 2015

Fuentes, Carlos and Lowe, Sarah M, *The Diary of Frida Kahlo: An Intimate Self-Portrait*, Abrams, 2006

Gates, Dorothy, *The Essential Guide to Upholstery*, Murdoch Books, 2000

Grant, Richard E., *A Pocketful of Happiness*, Gallery, 2022

Holmes, Cas and Kelly, Anne, *Connected Cloth*, Batsford, 2013

Holmes, Cas, *The Found Object in Textile Arts*, Batsford, 2010

Holmes, Cas, *Stitch Stories*, Batsford, 2015

Holmes, Cas, *Textile Landscape*, Batsford, 2018

Howard, Constance, *The Constance Howard Book of Stitches*, Batsford, 1979

Hunter, Clare, *Threads of Life*, Sceptre, 2019

Juniper, Andrew, *Wabi Sabi: The Japanese Art of Impermanence*, Tuttle, 2003

Parker, Roszika, *The Subversive Stitch*, The Women's Press, 1984

Zoob, Caroline, 'Stitcher's Journal', Issue 11, September 2021

Index

Acknowledgements

Deena Beverley would like to thank the following for their help and support in the making of this book:

My family in Wiltshire and Norfolk, for patiently accepting that I would be, as I always am when working on a book, as lost, or perhaps found, in its pages as I hope readers will become. Books consume me as much as I consume books, and this one has been especially hungry of my time and attention. Thank you for supporting me in every way that you do.

Andrew Newton-Cox for his beautiful and sensitive photography both of my work and the collaborative pieces.

Rainbow Silks for speedily efficient supply of fantastically useful and inspiring materials and always service with a smile, somehow even translated into online supply, in itself quite a feat.

The groups **Textiles and Stitch around Marlborough** and **Newbury Creative Stitchers** for providing local access to world-class speakers and workshops in convivial environments, which are my monthly injections of what I call alternative Vitamin C; colour and connection through textiles.

Susie Ford for bringing colour, inspiration and vitality into my life through your online presence despite the challenges you face, and for your permission to base my piece 'Beltane' on you as my muse.

The House of Smalls for providing an artist-friendly online gallery space throughout lockdown, evolving into an inspiring real-life gallery, and for being patient with my submissions being so last minute during the production of this book.

Ernest Wright Scissors for creating handmade scissors of incredible quality in Sheffield since 1902 that I've only recently discovered, but which are already trusted tools and, as such, friends for life.

Sheilagh Dyson for supplying beautiful eco-printed and dyed fabrics that I collaged into my rhubarb-preparation mixed-media piece, and for your friendship, support and encouragement.

Phillip Duigan and family for opening your home to me and Andrew Newton-Cox and providing such a warm welcome, despite our shoot interrupting your Christmas party. Your generosity of spirit is much appreciated.

Deborah Simmons for your friendship and gifted hand-worked lace, included in multiple pieces in this book.

All the contributing artists all over the world for providing inspiration and companionship, online and in person; your additions here are so appreciated.

Galleries, museums, pop-up exhibitions, groups, retailers, sellers of vintage and new textiles and ephemera, art-supply shops, bookshops, markets, car boot sales, charity shops, online marketplaces and all the spaces virtual and real which make making textile art such a joyful, life-enhancing activity: I thank you all for bringing the beauty, the tools and materials, and the knowledge and inspiration to make what I make into my life on a daily basis. Without you all, *Soulful Stitch* would still be a concept rattling around my busy brain, rather than the book it has become, along with all the new work created for it and the relationships forged and deepened along the way.

Deena Beverley
www.deenabeverley.com
Instagram @deenabeverley
Facebook Deena Beverley

With thanks to:

Deborah Simmons (facebook.com/DeborahSimmons) for supplying the handmade crocheted lace using vintage thread, worked to a vintage pattern.

Norfolk Museums Service, for permission to use images of the work of Lorina Bulwer.
www.museums.norfolk.gov.uk

Zak Foster, for permission to use extracts from interview with Lou Gardiner.
www.zakfoster.com

Photography of Deena Beverley's work, collaboratively created pieces by Deena Beverley and Cas Holmes, also John Craske's original work, held by and made available for photography with the kind permission of the Duigan Family Collection.

Cas Holmes

Heartfelt thanks go to the artists, makers and professional colleagues who have generously contributed to the images and words in this book. Their details are featured on pages 124 and 125.

To my family, friends and work colleagues for their support during the writing process. That I am able to continue to create, work and to contribute to the soul of this book is down to you.

For those who learn alongside me on courses whose wise observations allow me to grow as I teach.

Lou Gardiner our time to talk was too short, but the joy and beauty you found in the world lives on.

To Nicola Newman, our editor Bella Skertchly and the Batsford team for their patience and advice in bringing this publication together.

To Jacqui Hurst and Andrew Newton-Cox for the beautiful photography of our artworks.

Image Credits

Photography by Andrew Newton-Cox and Jacqui Hurst

Andrew Newton-Cox Photography
www.andrewnewton-cox.photography
Instagram @andrewnewtoncoxphotography

Jacqui Hurst Photography
www.jacquihurstphotography.com
Instagram @jacqui.hurst.photography

Additional images supplied by:
Melissa Averinos 64, 65; Ben Bender 74t, 74b; Allan Brown 110, 111m, 111b; Lorina Bulwer 70, 71l, 71r; Mark Carroll Photography 111t; Sam Chick 86t, 86b, 87; Sheilagh Dyson 100; Louise and Ben Gardiner 88–89, 91t, 91m, 91b; Michala Gyetvai 117l, 117r; Cas Holmes 24b, 33t, 46, 47, 56–57, 66t, 67, 80, 81, 83; Angela Hunter 48, 49t, 49b; Vanessa Marr 92, 93t, 93b; Anastasiia Podervianska 68–69, 69.

Images for John Craske (page 26–27), Mair Edwards (page 50–51) and Jo Smith (page 60–61) sections by Andrew Newton-Cox.